# THE ESSENTIAL • BOOK OF
# Drawing

# THE ESSENTIAL • BOOK OF

# Drawing

## A guide to creating great art

## Duncan Smith

ARCTURUS

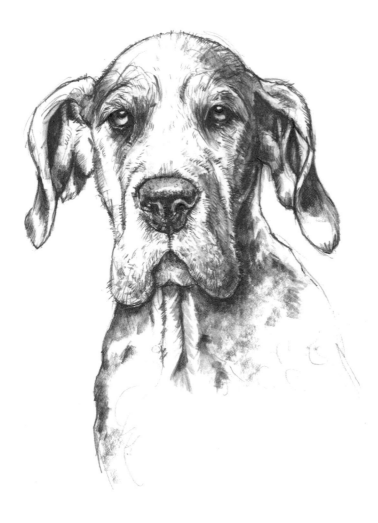

ARCTURUS

This edition published in 2015 by Arcturus Publishing Limited
26/27 Bickels Yard, 151–153 Bermondsey Street,
London SE1 3HA

ISBN: 978-1-78404-216-5
AD004147UK

Printed in China

# Contents

# Introduction

## The delights of drawing

People often ask me, 'How can I learn to draw as well as you?' My answer is always the same: 'Patience, practice and perseverance.' If you really want to improve your drawing skills, just draw – every day. Go to drawing classes, watch other artists as they draw, get hold of good drawing books and follow the tips and expert advice. As you become more practised and confident, you will find your own style.

I began to draw at an early age and managed to improve my skills by watching my older brother John draw, by following the three Ps, and by gaining the help of a talented and enthusiastic art teacher at secondary school. I was then lucky enough to go on to Glasgow School of Art. Imagine, as a child, how you would feel on Christmas Day if you woke up and found you had been given all the presents you ever wanted . . .

For me, that was my art school experience. Suddenly I was surrounded by like-minded people and talented artists who were happy to pass on their knowledge and expertise to me.

There is no great mystery to drawing; as with anything new, there are some basic rules and once you learn these the rest is just having fun and watching how quickly your skill develops. In this book I've covered many of the genres you might want to draw – portraits, figures, landscapes, still lifes and animals. In the step-by-step demonstrations in these pages you'll follow the process I go through, from initial sketch to finished drawing. By putting into practice all the advice in this book, you'll find that you will amass a great set of drawings. And, by seeing how much your drawing skills improve, you'll be encouraged to continue on your journey to becoming a true artist.

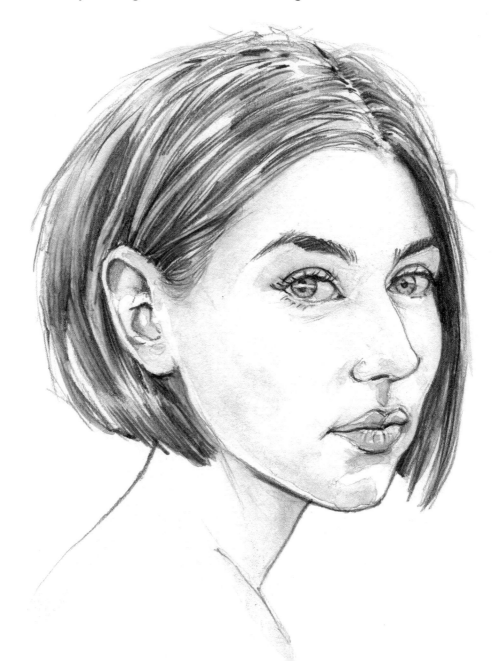

# Tools of the trade

There is a wide range of artists' materials and tools available, but all you really need are the basics: some good pencils, a cartridge pad, an eraser and a pencil sharpener. We shall explore other media as we go along.

## Pencils

I like to use B grade pencils; these are soft and give a lovely range of tones from pale grey to jet black, depending on the pressure you apply. A good set to acquire would be 2B, 3B, 4B and 6B – the higher the number, the darker and softer the lead. HB pencils (mid-range) and those in the H grades give a very hard line and I don't recommend them for the exercises in this book.

Derwent watersoluble sketching pencils are wonderful; I use the Dark Wash 8B grade a lot in my work. Once you have made your drawing using the pencil, you can then load a watercolour brush with water and paint in the various tones you require. After the washes are dry, you can add more pencil to create darker tones if you wish. With some practice you will be able to create highly finished pieces in a short time by using this method.

## Paper

It's worth trying a selection of different papers to find the one you prefer for the medium you are using. As a rule of thumb, it's best to use a heavyweight (220gsm/100lb) cartridge paper for general pencil and charcoal sketching and for light wash work, since a thinner paper will buckle once wetted; a watercolour paper (300gsm/140lb) for watercolour work with heavier washes; and a pastel pad or tinted Ingres pad/paper for pastel or charcoal work as these have a toothed surface for the pastel or charcoal to adhere to. For finer pen or pencil work, I tend to use a smooth, lighter paper (130gsm/80lb), and marker pads are great for work using fine pens or marker pens. But it's really all about what you feel good working with.

You'll find some layout paper useful, too, as it's slightly transparent and will allow you to trace over your drawings or to work over the finished drawings in the book.

...ering
...sh you
...d sable

...my pencils
...Try to get
into the ha... – it's easy
to become so caught up in th... cess that you
don't notice your pencil has become blunt and
your work is starting to suffer.

## Erasers

There are many erasers on
the market, but I recommend
a putty rubber for all
purposes. It can be
moulded into a point to
remove fine lines and,
unlike other erasers, it
leaves no debris behind.

## Starting Out

Now you've discovered the basic tools and equipment you need on your adventure as an artist, it's time to learn how to use them with confidence. In this chapter, you'll find out how to hold your pencil to create different qualities of line and you'll see how easy it is to produce patterns and shapes using combinations of lines and tones. You'll explore the importance of lighting to create mood and atmosphere and learn how to bring your drawings to life using other media, such as charcoal, pastels and brush pens.

Keep the end of the pencil firmly tucked into the palm of your hand to do loose shading.

## Holding the pencil

Whichever way you like to hold your pencil is the right way for you, but there are still some useful tips worth learning. The examples here show you how most artists hold their pencils to achieve different techniques. Practise these methods and pretty soon they will become second nature to you.

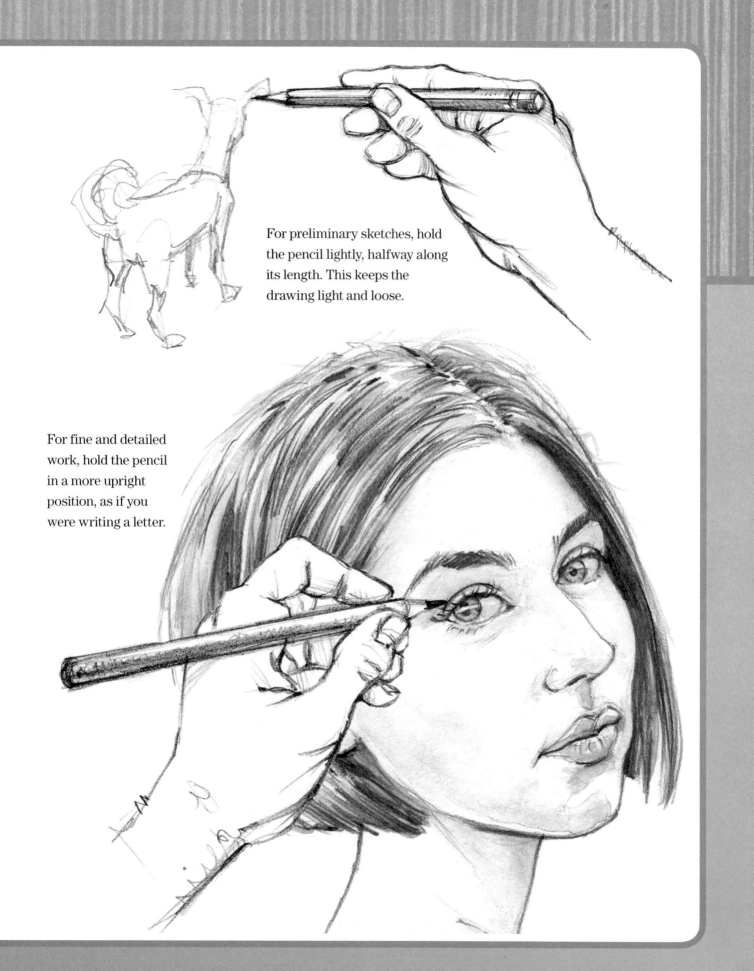

For preliminary sketches, hold the pencil lightly, halfway along its length. This keeps the drawing light and loose.

For fine and detailed work, hold the pencil in a more upright position, as if you were writing a letter.

# Making your mark

Grab your pencils and try copying some of the lines shown here. This allows you to try different pencil strokes and acts as a good warm-up exercise.

Lines that define the shape of an object are called contour lines; they help to create a recognizable form.

Here are lots of examples of lines that create tone – a term that refers to the dark and light areas in your drawing (shade, if you like). Cross-hatching is the most popular way to shade. Draw a set of parallel lines then cross over them with another set; you've just created some tone!

## Cross-hatching

## Contour lines

## Graduated tone

By varying the amount of pressure you apply, you can create a graduated tone. Try making some of these marks using a soft pencil, such as a 4B, first pressing down hard and then starting to reduce the pressure so that your marks go from dark to light.

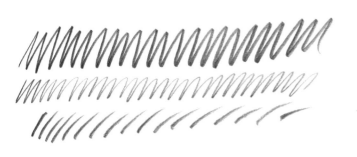

## Pattern, tone and decoration

Take a look at the drawings below, and you'll see how by using a variety of the lines I've shown you here, you can create pattern, shape and tone in your drawings. Have fun, enjoy creating and doodling different lines. After some practice, you'll be able to include these marks in your own drawings.

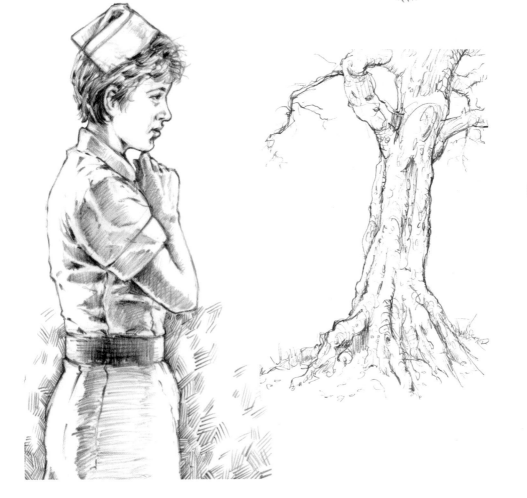
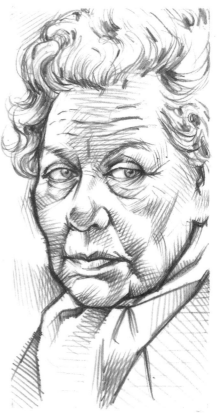

# Using charcoal

Charcoal is a great medium to draw with; whether you use willow charcoal, compressed charcoal or charcoal pencils, all allow you to create subtle tones and rich dark blacks. The use of charcoal dates back thousands of years to prehistoric cave paintings. It's a deeply rewarding medium but very messy, so experiment and become accustomed to how it handles before you start a major drawing.

For fine detail, always use the point of the charcoal or a sharp charcoal pencil. When you need to cover large areas with tone, break off a piece and use the side of the stick. You can smudge charcoal with your finger or, for more accurate blending, with a tortillon or paper stump (I call these 'smudge tools') in much the same way as you would use a pencil. You can lift out highlights or draw into the charcoal with an eraser, and you can even use a brush to lift off tone or add subtle highlights.

I simply break a charcoal stick in half and use the sharpest piece to draw with. To keep charcoal pencils sharp, I use a craft knife (remember to take care and always angle the knife away from your body). To get a really fine point, I gently rub and roll the end of the charcoal on a sheet of fine sandpaper. Then I clean the point with a tissue to remove any fine dust before drawing. You can buy sandpaper blocks in most art stores or just cut a sheet of fine sandpaper into strips and staple them together.

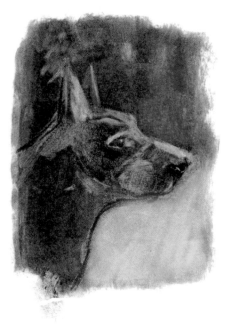

The dog's head was drawn using the sharp end of the charcoal stick for the details and the side for the tone. The lighter tones and highlights were lifted out with a putty rubber.

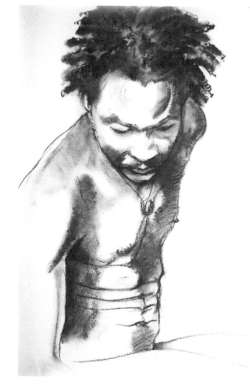

I drew the figure on the right entirely with a charcoal stick and lifted out the highlights with a putty rubber.

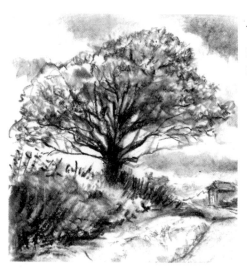

The tree was a mix of charcoal stick, pencil and tortillon, while a putty rubber shaped the clouds.

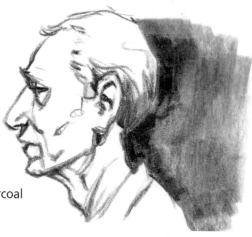

The old man was drawn with charcoal pencil, smudged with a finger.

For the pig, I used a charcoal stick and spread some tone with my finger.

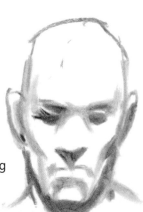

I drew the bald man with a charcoal stick and developed the subtle shading by adding tone with the tortillon.

# Light and shade

The area where light hits your subject matter most strongly is called your highlight. The side of your subject that faces away from the light is your shadow. In between the highlight and shadow is an area of graduated mid-tones. When light hits the surface next to the subject it creates an area of reflected light, which bounces back on to the subject to produce a patch of lighter tone in the dark-toned area.

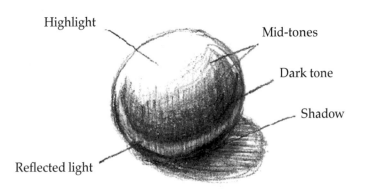

Highlight

Mid-tones

Dark tone

Shadow

Reflected light

The mood of your drawings is affected by the direction of light and how strong or weak the light is. By changing the position of your light source, you can communicate a very different mood and emotion to your viewer.

Light brings your drawings to life and creates a three-dimensional result. You can decide whether to leave your subject lurking in the shadows or bring it into the open in bright light.

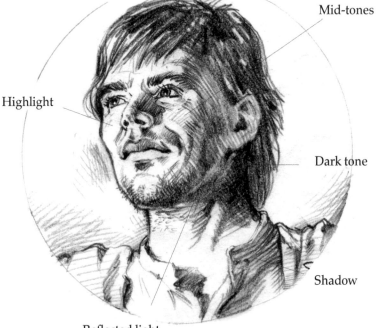

Mid-tones

Highlight

Dark tone

Shadow

Reflected light

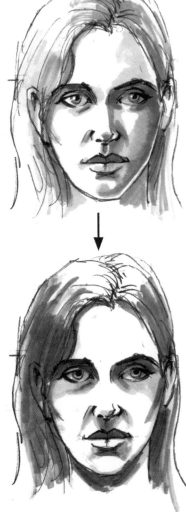

Here are three drawings of the same girl, with the same expression. The first shows the light source coming from the side, the second shows the light source coming from above and the third has the light source coming from below. You can see how the mood and expression seem to change.

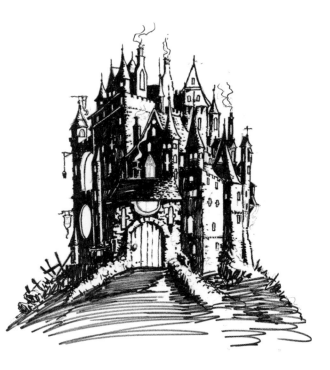

The castle has stark lighting with solid blacks and dark shadows, which help to create a creepy, unsettling atmosphere.

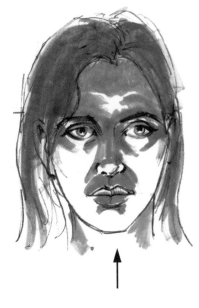

The drawing on the right is starkly lit, but the shadows created by the blind also help produce a *noirish* feel, suggesting the figure could be a character from a pulp detective novel or a would-be spy.

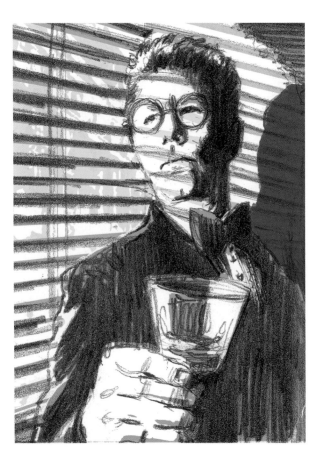

# Pastels, brush pens and watersoluble pencils

Artists have been using pastels since the early Renaissance period. One of the first to be known internationally for her pastel work was self-taught Venetian artist Rosalba Carriera, whose vibrant portraits were popular in the late 1600s. Maurice-Quentin de La Tour and Jean-Baptiste Perronneau were two rival Rococo artists who dominated what was a golden age for pastel portraiture in the 18th century. Others include John Russell, Eugene Delacroix, Jean-François Millet, Édouard Manet, Edgar Degas, Toulouse Lautrec, Auguste Renoir and Mary Cassatt – to name but a few.

Pastel is a wonderful medium for creating colourful, impressionistic or highly finished work. You can use it like charcoal, drawing with the pointed end, blocking in large areas of tone or colour with the side of the pastel and blending the colours with your finger or a tortillon. For more detailed work, use pastel pencils which, like charcoal, should be kept sharp at all times.

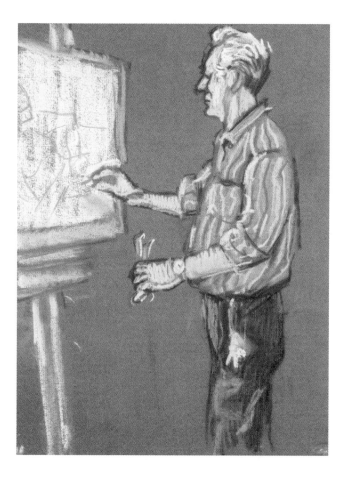

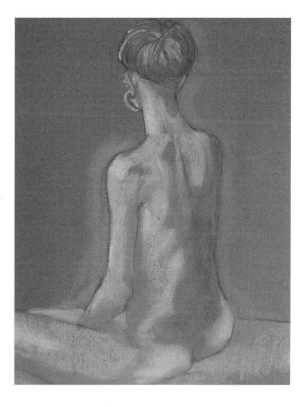

Toned pastel paper gives a mid-tone or shadow value which you can use to good effect. For this image of an artist, I allowed the paper to shine through as a tone in the shirt and trousers, and in the mid-tones of the flesh and background.

Similarly, for the seated nude I left the tone of the paper as background and as some of the skin tones, in the same way that you would leave white shining through for highlights when using white paper.

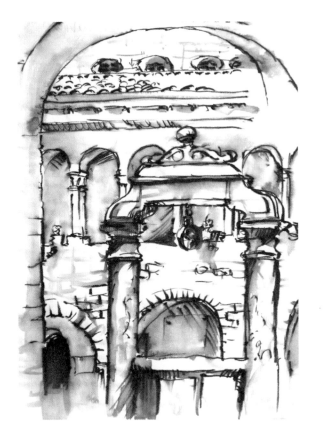

A brush pen is essentially a felt pen with a brush head, which gives a fantastic range of variable brush strokes. It is one of my favourite tools for drawing as I can use it for line, then load a brush with water to create all the mid-tones, leaving the white of the paper for highlights.

The same applies to watersoluble pencils – they are just like normal pencils, but you can add water to create soft or dark washes.

After making the line drawing of this archway, I used a brush and clean water to put in the range of tones, taking care to leave areas of white paper for highlights.

The street scene and the figure below were both done using a Derwent Dark Wash 8B watersoluble pencil. After completing the drawings I added several washes to create the feeling of depth and tone.

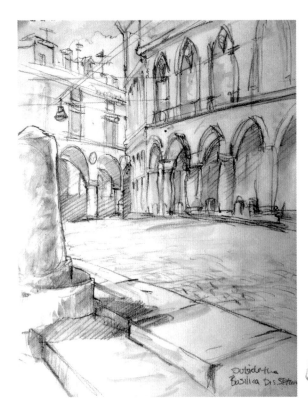

# Sketching the world

Drawing is all about hand–eye co-ordination; if you practise every day and draw exactly what you see in front of you, your skills will rapidly improve. This is where sketchbooks come into play.

Using a sketchbook is like writing a private diary – it's something you can keep to yourself to chart your progress without worrying about what people will think of your work. Alternatively, you can share your sketches with others to get some constructive feedback.

Try to carry a sketchbook with you at all times – an A5 one will fit into a pocket or bag. I draw when I'm on trains, buses and even on the plane going on holiday. I have sketchbooks stashed around different rooms at home in case inspiration for a drawing presents itself. Once you get into the habit of using your sketchbook daily, you'll be amazed at how much your confidence and drawing skills improve.

## Fast and loose

Don't make the mistake of trying to do finished drawings in your sketchbook – initially you want to capture just the pose, the movement, the shape of your subject. Later, with more practice and experience, you can do more complex drawings. Here you can see my sketchbook work – some of it is incomplete because the model got up and walked off! Other drawings are more finished, but still fairly loose and sketchy.

Think of sketchbooks as ideas for later. Try to relax and enjoy doing these drawings – if they work out that's great, but if they don't there's always something else to draw around the corner. Don't be afraid of doing multiple drawings on one page, as it often makes for an interesting composition.

## Gesture drawing

It's a good idea to warm up by doing some gesture drawings. In these, the purpose is to capture the movement or spirit of the subject. Gesture drawings should be done quickly, in no more than two minutes. Remember it's not about the detail; you just want to get a feel for the subject (see the drawings of dogs, below).

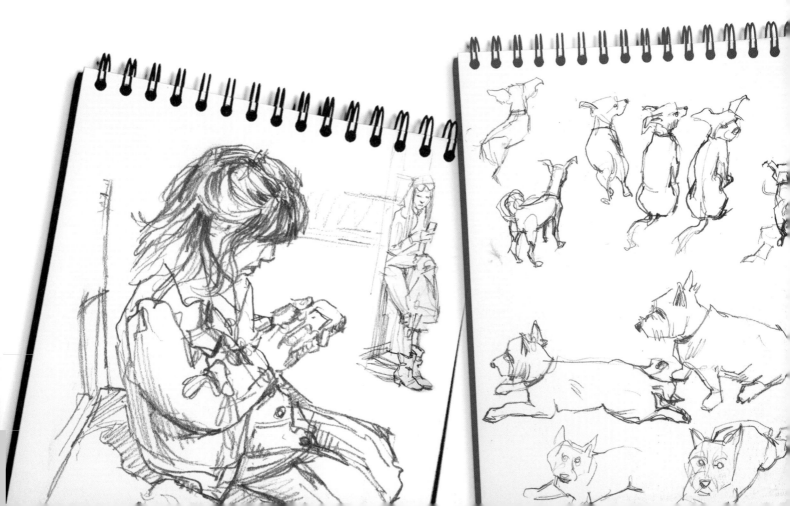

# Drawing faces

There are many ways of drawing the human head, and if you look at the work of the Old Masters you might conclude it's a very difficult thing to do. But it need not be: by following these simple steps you should get a quick grasp of how to do it.

See how I have divided up the skull with three horizontal lines – at the eyebrow, the bottom of the nose and the mouth – and a vertical centre line.

Eyebrows

Ear

Mid-point of face

Nose

Mouth

## Step 1

First, draw an egg shape for the head. Divide it with a vertical line and add a horizontal line for the eyebrows, just above the halfway mark. Draw a second horizontal line almost halfway between the first line and the bottom of the chin; this is the base of the nose. Now add a final horizontal line about a third of the way between nose and chin; this marks the position of the mouth.

## Step 2

Now draw in a couple of dark lines for the eyebrows and two ovals for the eyes. The gap between the eyes should be the same width as an eye itself. Draw two half ovals either side of the head from the eyebrow line to the nose line – these are the ears.

## Step 3

Draw a half-oval shape above each eye to create the eyelids, then draw in the eyes. Add a line for the bottom of the lip and two small lines for the nostrils.

## Step 4

Take time to add some detail to the features – the rest of the nose, the top lip and the eyebrows – then add a hairstyle of your choosing. You have drawn a simple head, in four easy steps.

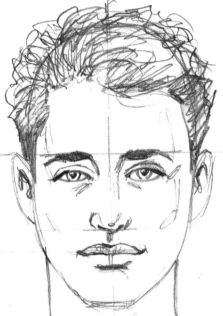

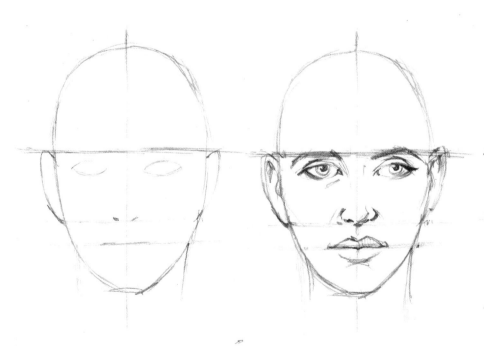

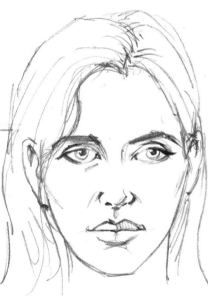

## The female head

Here's another step-by-step, this time showing a female head. The only difference here is that, in general, the female jawline tends to taper more and the lips are slightly fuller than the male's.

# CHAPTER 2

## Face to Face

This chapter introduces you to detailed step-by-step demonstrations, where you can follow how I develop the various subjects. Each stage of the drawing is approached in a simple fashion and slowly builds up to a finished piece. As the title suggests, this chapter is about faces – different types and ways of drawing them, using media such as pencil, wash, charcoal and ink.

For a good portrait, it's important to learn about proportion and perspective, and practise drawing accurate contours and creating precise shading. Taking careful measurements is the key to getting a likeness of the person you're drawing. The picture you have in your head of a human nose may not look like the nose on the face of your subject. You need to draw what you can really see, not what your brain is telling you from memory and preconception. This isn't as easy as it sounds!

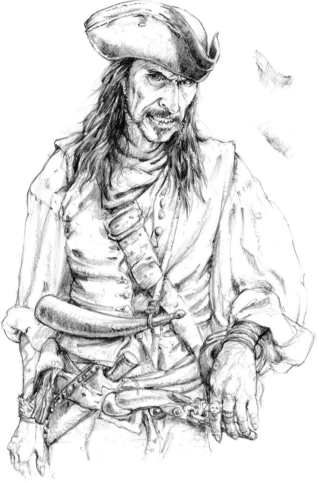

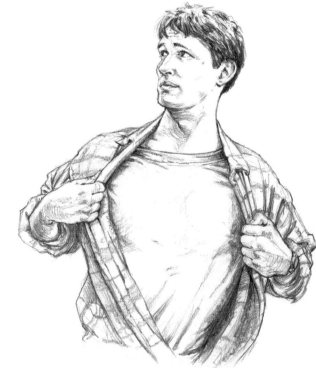

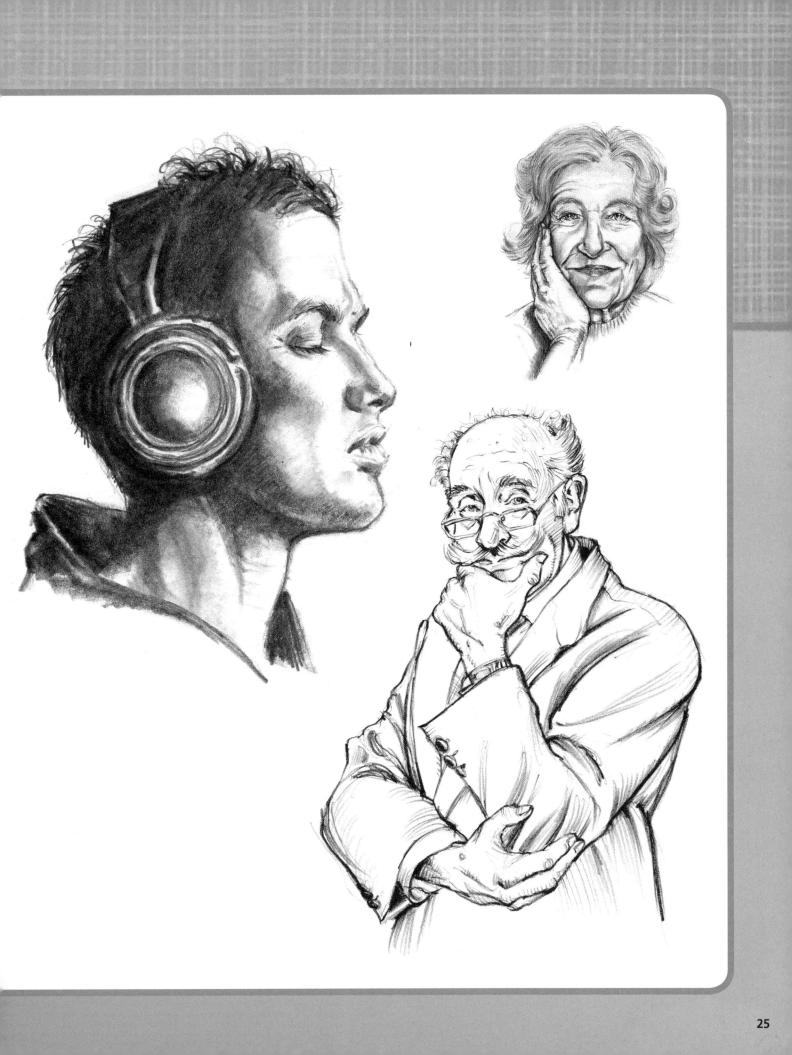

# Femme fatale

I found a photo of my wife where she looks like one of those glamorous Hollywood femmes fatales. I thought it could make a striking drawing if I accentuated the contrasts.

**MATERIALS AND EQUIPMENT**

2B pencil
Brush pen
130gsm (80lb) cartridge paper
Putty rubber

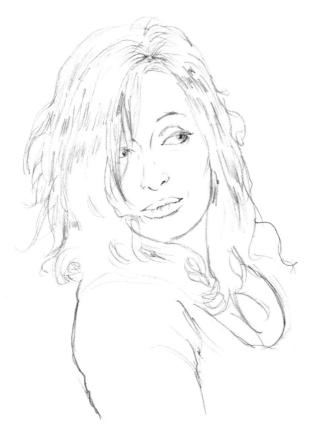

## Step 1

First, as I was going to make this a stark black and white drawing, I used my 2B pencil to sketch out the face and hair. I didn't want any tone or detail apart from in the hair, so I kept everything as pure line. I indicated where the highlights in the hair would be and suggested the direction in which it would flow.

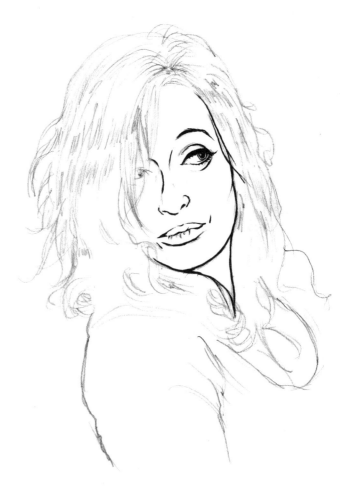

## Step 2

I used the brush pen to ink in the face; it's just like using a paintbrush, but you have more control with a pen. I varied the weight of the lines, especially around the eyes and lips, to avoid the drawing appearing flat. At this point I wondered if I'd put too many lines in the face, but decided to revisit this issue later on.

## Step 3

I followed the direction of the hair with my pen, carefully avoiding the highlights. I varied the weight of the pen to create thick and thin lines, just as you would with a pencil. Pleased with the way the hair was progressing, I finished off this step by adding a darker shadow under the chin.

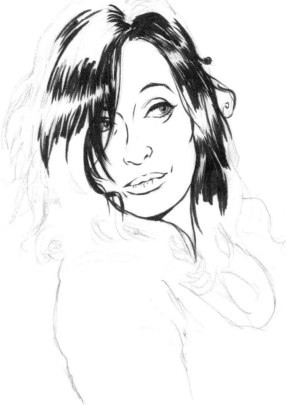

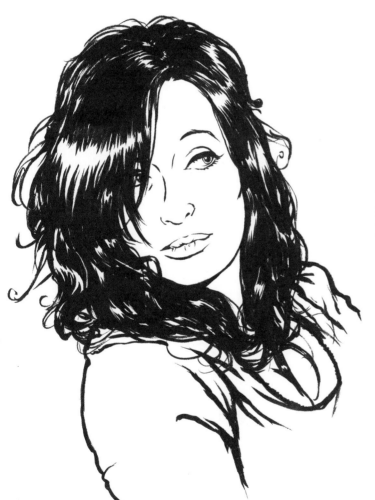

## Step 4

Removing the pencil lines with a putty rubber immediately made the drawing look fresher. From here on I took my time. Using the original photo as reference, I followed the shape of the hair and made sure my highlights curled and turned as though a believable light source was bouncing off the hair. I added more black ink to frame the face and the minimal features. I took care to add flyaway hair in places and then drew in the T-shirt with just a few lines. I stepped back and realized that, as I suspected earlier, there were too many lines in the face. I used white gouache to remove the lines under the eye, around the nose and beside the mouth.

**TIP**

Always work from left to right so that you don't smudge your drawing – unless you're left-handed, of course, when you need to work from right to left!

# Pirate

I met this amazing pirate at a historical re-enactment fair. I didn't have my sketchbook handy, but I persuaded him to pose for some photos, which I used later as reference to draw him in pencils.

## Step 1

I began by doing a fast sketch using a 2B pencil, drawing the top part of the figure while paying close attention to the reference photo. I drew the basic elements of the face then switched to a 4B pencil and started adding detail to the darker areas around the eyes, making sure I got his scowl looking just right. Next I indicated the dark hair coming from underneath his hat.

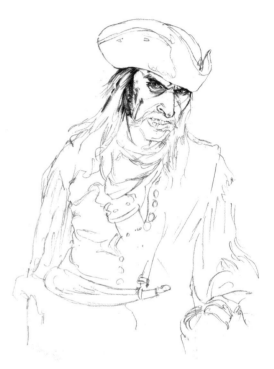

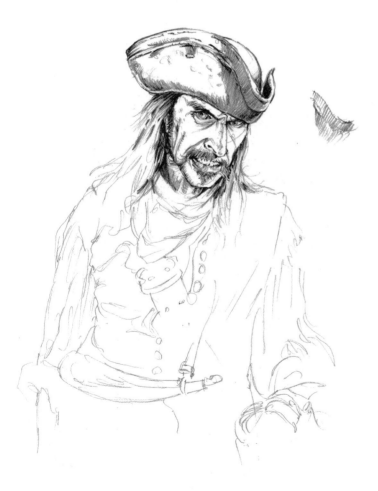

## Step 2

I added all the dark areas using a 4B pencil, then switched to a 3B for the lighter areas of shadow, such as under the eyes and the line of tone on the nose (you can use a 2B if you prefer). I started work on the hat, using the 3B pencil to shade in the tone and build it up in directional lines to give a three-dimensional effect. I added some rumples here and there to make the hat look battered. Then I worked on the pirate's moustache, leaving some white areas to suggest the light falling on the right-hand side. I added a suggestion of teeth and gums and put in some tone on the neck.

## Step 3

Using a 4B pencil, I set to work on the hair, drawing in the dark areas and leaving the highlights as white paper. It's always important to look closely at where the highlights are and how the hair twists and curls, as this will make your drawing more realistic. As I drew, I adjusted my pressure on the pencil to produce variations in tone. I added shading to the waistcoat and belts with the side of the 3B pencil, keeping it tucked into the palm of my hand. Again, I just suggested shadow and tone on the belts and the folds of cloth. I sketched in the rest of the figure and added some darker lines to the shadow on the hat.

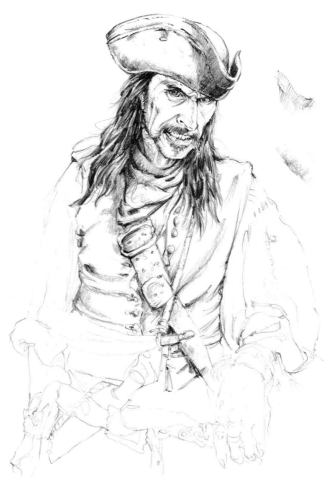

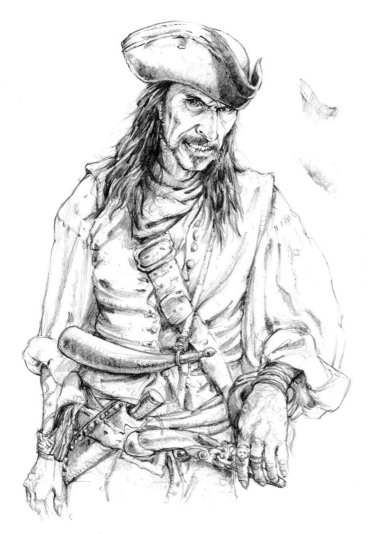

## Step 4

Using a mix of pencils – 2B for the lighter areas, 3B for the mid-tones and 4B for the darker areas – I completed my pirate drawing. I gave the gunpowder horn 4B tone in the middle, then 2B lighter tone at the bottom to suggest reflected light, and a 4B dark line for the edge. I put in the shadows of the shirt using the side of the pencil, then added some lines and curls to give the clothes a worn look. I drew some tattoos on the arms and hands and added darker tones to the shadow areas. I added more stubble and stray whiskers to the face and flyaway strands of hair to suggest movement. Then I added more tone to the pirate's temple, cheekbones and nose. Finally, I completed the hands, musket, knife and cutlass handle on which his hand is resting.

# Headphones

If your model finds it hard to relax it's a good idea to distract them by setting up something they enjoy, in this case listening to music, so that they're not so aware of you drawing them. This frees you to focus on your own enjoyment of the drawing.

**MATERIALS AND EQUIPMENT**

Derwent Medium Wash 4B watersoluble pencil
130gsm (80lb) cartridge paper
Putty rubber
Tortillons or paper stumps

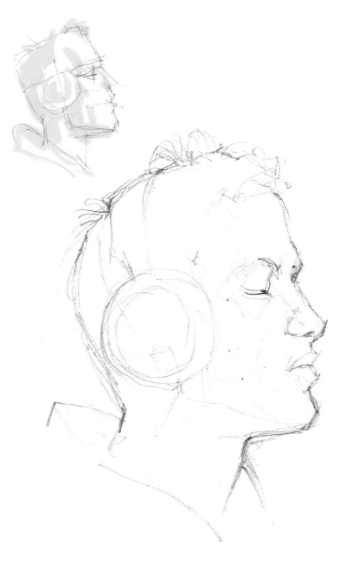

## Step 1

Half-closing my eyes so I could see the tone more clearly, I did a little doodle of the head to establish its shape and where the tone would go. Then I started on the main drawing and lightly sketched in the whole head.

## Step 2

There was a strong light source coming from the right and above, so I added dark tone with the side of the pencil and blocked in a dark line round the side of the head, cheek and chin. Using the point of a tortillon, I pushed out tone from the headphones to the cheek and chin, then used the side of it to draw out and blend the lighter tone. I added some more pencil to the eyebrow and nose and blended as before. The aim here is to keep the cheek and nose a lighter tone than the back of the head, as less light falls there.

## Step 3

Using the side of the pencil, I started to add the dark shadow tone behind the neck and on the hair at the temple. I added some details to the eyes and lips with the sharp pencil point.

## Step 4

I stepped away from the drawing to check from a distance that everything looked in proportion; it's helpful to do this from time to time as you can get so caught up in your drawing that you miss simple errors. For the most part I was happy with my portrait, but I saw that I needed to extend the skull at the back.

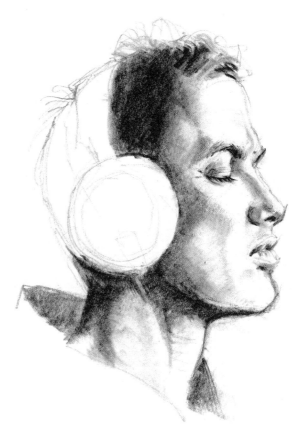

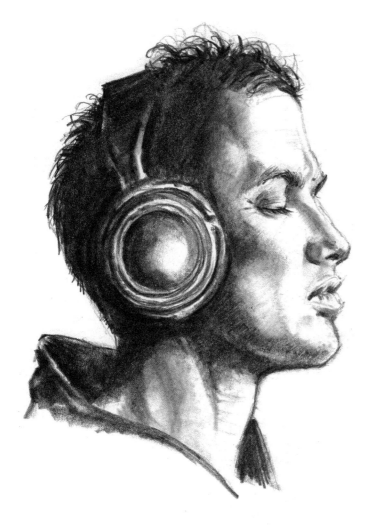

I carried on as before, adding black to the back of the head, then, using the sharp pencil point, I added spiky hair strands from under the headphone at the back and front. I added tone to the top of the headphone and used the tortillon to lift off the little highlight. (You can do this later with a putty rubber, if you prefer – just break off a piece, roll it into a point and draw in your highlights.) I added some darker tones round the cheek and neck, then worked on the band of the headphones, using dark pencil to leave an edge and dragging over some tone with the tortillon so that the highlight wasn't too stark. I took a few minutes to make the circle of the headphone look believable, again watching where the light fell, so that the dark tone at the back faded to mid-tone, then to the burnished highlight. Finally I cleaned up the drawing with my putty rubber so it all looked crisp and fresh.

# Three-quarter portrait

You have to think more three-dimensionally when drawing a three-quarter portrait. This is where guidelines will help. I start with a little sketch to get the proportions right, then divide the head vertically down the centre. I add the three horizontal lines, as shown on page 22. Once I have the guidelines in place, it's easy to add in the features accurately.

## Step 1

For the main sketch, I took my time to establish the structure and proportions of the face, paying attention to the little sketch to make sure everything looked in the right place. Because this was to be a wash drawing, I kept the initial sketching fairly light.

## Step 2

I noticed that I had made the model's top lip too full, so I redrew this before carrying on. Never be afraid to change your drawing when you see something you're not happy with – if you don't address it immediately you'll give yourself more work later on. Next I defined the eyes and eyebrows, adding highlight in the eyes for a little sparkle. I deliberately didn't add the eyelashes, deciding to leave the small details until I had finished the tonal wash. I did a little work on the hair, including the area of dark tone away from the light.

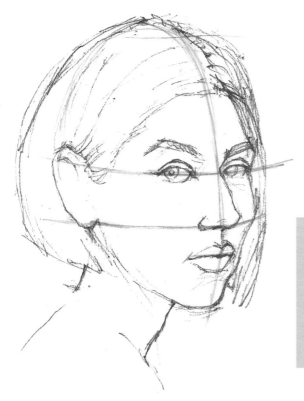

**MATERIALS AND EQUIPMENT**

Derwent Medium Wash 4B watersoluble pencil
No. 6 round watercolour brush
220gsm (100lb) cartridge paper (I used one with a smooth surface)
Putty rubber
Tissues

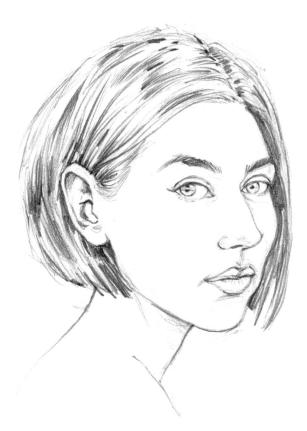

## Step 3

The next step was to strengthen the drawing, adding weight to the lines. When using pencil it's important to think ahead, as the tone you put in now will help with the washes you add later. I varied the weight of my line according to where the light fell on the hair – it was darkest where it was tucked behind the model's ear. Then, after adding some more shadow under the chin, I was ready to add a wash.

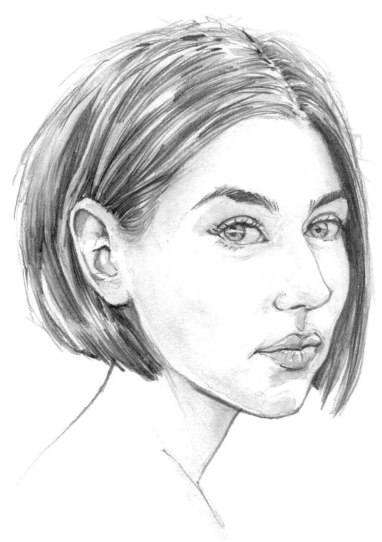

## Step 4

I loaded my brush with water and washed it under the eyebrows to put in the dark tone. That's the beauty of these pencils; they allow you to create dark washes in a painterly way and if you want to soften areas of mid-tone you simply add more water. I like to create my washes of tone this way, but you could also draw some heavy marks on a separate piece of paper and add water to these to create your tone, using the paper as your palette. I keep a clean tissue handy to soak up any excess water as I work.

I carried on with my washes, letting the water create shadow areas round the cheeks, nose and chin and leaving the white paper as highlights. I laid a light wash of water over the hair to create a general tone and added the darker tones, allowing the water to do the work.

I finished by adding the shadow under the chin and then, taking my sharp pencil, I put in all the small details such as the eyelashes. Don't overdo these – you just want a suggestion, not every lash. I also went over some parts of the hair where the tone had faded.

Finally, I went back to the eyes and added a wash of shadow on the whites – this makes the highlights pop out more and engages the viewer with the subject.

# Professor

This is a drawing of my lovely neighbour, Les, looking like a mad professor who has just stepped out of a retro sci-fi show. A great sport, he offered to pose for me – how often do you get the chance to draw a handlebar moustache?

**MATERIALS AND EQUIPMENT**

3B pencil
220gsm (100lb) smooth surface cartridge paper
Putty rubber

## Step 1

I made a little sketch first to loosen up my hand. It's important to look for visual clues to help you get the pose right. Here, see how the line of the head links up with the left hand and follows down to the elbow, where the fingers of the right hand point up to the shoulder and the wrist leads you back to the other arm. Tricks like this help to get the proportions and pose correct. Having established the pose to my satisfaction, I made my initial line drawing.

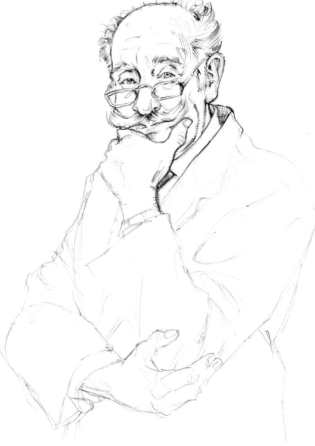

## Step 2

I started work on the face, putting in tone at the side of the head with cross-hatching and adding detail to the hair and handlebar moustache. I drew some freckles on the top of the head.

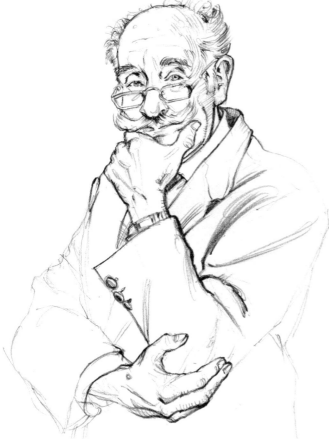

## Step 3

Next I worked on the hands, again suggesting tone with lines and cross-hatching. I started on the jacket, paying attention to the details of the buttons on the cuffs.

## Step 4

After defining the glasses, I added some darker tone around the head and jacket. I strengthened the lines of the figure and took a moment to consider if I needed to do more before deciding that I was happy to stop there. It's easy to overwork a drawing and ruin it, so when you feel your picture is nearing completion just step back or take a tea break so that you gain a fresh perspective.

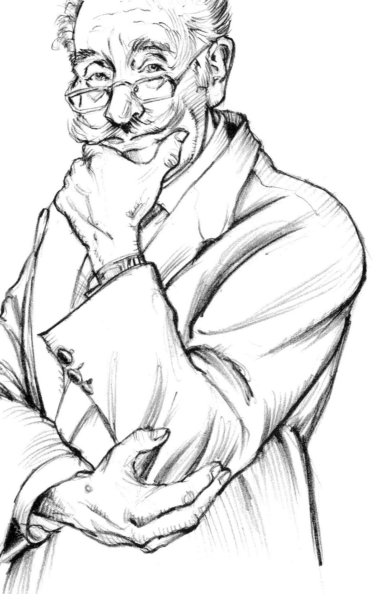

35

# Charcoal kid

My reference here was a photo I took of a friend's daughter. I thought turning it into a charcoal drawing would be an enjoyable challenge.

## Step 1

First, using a charcoal pencil, I doodled a quick sketch to see how the final drawing might look. Then I took my time and slowly sketched out the pose again with the pencil, keeping a clean sheet of paper under my hand to avoid smudging the drawing. At this stage I simply made an outline drawing.

## Step 2

Next I used a tortillon to smudge the tone around from the charcoal line. I paid attention to the areas of shadow in the picture and followed these as closely as I could. Again, I worked slowly, keeping the drawing fairly clean, and soon had what looked like the beginnings of a pleasing portrait.

## Step 3

It was time now to add the darker tones, which I did with a mixture of charcoal pencil and stick. I blended them in with the tortillon, making sure I left some of the paper white where the highlights fell. Next I worked on the eyes with a finely sharpened charcoal pencil, picking out the detail before suggesting some of the darkest tones in the hair. I added detail to the mouth and teeth – not a lot, just a suggestion, since with charcoal less is sometimes more.

In the photo the girl is surrounded by a dark background that throws her fair hair forward, so I decided to try this at the bottom of the drawing, using the side of a charcoal stick. I wasn't sure about this, so I took a break before moving on.

## Step 4

I decided to add black to the rest of the background, applying it with the side of the stick where possible and elsewhere using the point to go carefully around the edges, drawing a dark tone and pushing out from there. Where this was tricky, for example around the flyaway hair, I tried to leave a white line. You could do this or just draw over it and lift the tone out later with a putty rubber or some white charcoal or pastel. I faded the tone towards the edges with a tortillon.

Returning to the hair, I used the stick for large areas of tone and the pencil for the finer details. I finished the detail in the fringe and suggested blocks of tone in the hair at the bottom. I put in some darker lines in the eyes, the nostrils and the corners of the mouth, then, tearing a piece off my putty rubber and modelling it to a point, I lifted out the flyaway hairs at the sides and cleaned up parts of the image I had smudged. In lifting out highlights in the eyes I smudged the pupils, so I carefully redrew these and added in highlights again to complete the portrait.

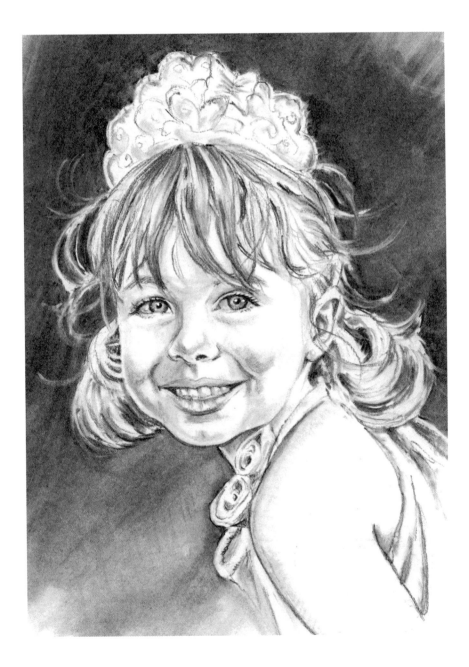

### MATERIALS AND EQUIPMENT

Medium willow charcoal sticks
Derwent dark charcoal pencil
White charcoal or pastel (optional)
130gsm (80lb) cartridge paper
Putty rubber
Tortillons or paper stumps
Sharp craft knife
Sandpaper

# Superman!

This drawing is based on a photo of a friend of mine, Iain McCaig, pulling back his shirt in a gesture typical of an action superhero.

**MATERIALS AND EQUIPMENT**

Derwent Medium Wash 4B watersoluble pencil
220gsm (100lb) smooth surface cartridge paper
Putty rubber

## Step 1

I started with my usual doodle to work out roughly what I would be doing. Then I lightly sketched in the proportions of the figure and head. In the reference photo my friend was standing upright, but I tilted my figure to the right slightly to give the illusion of motion and add a little drama.

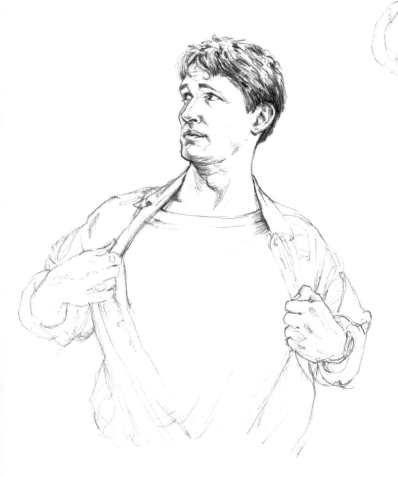

## Step 2

Next I started to add the details to the face. I wanted to capture the emotion in the eyes and eyebrows – our hero is looking to the heavens and at any moment he will leap into action! I spent some time drawing in the curve of the eyeball and the tilt of the eyebrows. I reinforced the determined look around the mouth – the lip turns down and then up at the edge. I followed the shadow under the chin and started to add the darkest tones around the neck and hair.

## Step 3

To bring the drawing to life, I added all the dark tone to the hair, leaving the white of the paper as highlights. I darkened the area around the eyes and added shadow beside and under the nose. The head and neck were now almost finished. Using a combination of the side of the pencil and fine lines with the sharp point, I added tone to the rest of the figure, first the shirt and then the hands and arms. I drew in the darkest lines on the shirt, where all the folds and pulls were, and suggested folds on the T-shirt at the chest and waist. This again helped to suggest that the figure is in movement.

## Step 4

I had intended to add a wash of water at this stage, but was happy with the way it was looking so decided to keep it as a pencil drawing. As I had started using a watersoluble pencil, I continued with this medium. With the side of the pencil, I put in the checks on the shirt, following the folds where the pattern twisted and turned. Take your time when doing a pattern such as this, because if you don't follow its direction the image will look distracting and flat. Finally, I went back to the eyes to reinforce the highlights, and added more tone under the eyes, chin and neck. Lastly I went over some of the lines to add darker tone. Now our hero is ready to leap into action – up, up and away!

# Smile

I enjoy the challenge of trying to capture the likeness and character of the more mature face. I used charcoal here to give the drawing a soft, relaxed feel. I kept the focus on the head and hand by fading out the rest of the figure.

**MATERIALS AND EQUIPMENT**

Medium willow charcoal sticks
Derwent dark charcoal pencil
Grey compressed charcoal sticks
Ingres paper
Putty rubber
Tortillons or paper stumps
Sharpener or craft knife

**TIP**

Blend large areas with the side of the tortillon or paper stump. For finer detail where you need more control, use the point like a pencil.

## Step 1

After a quick doodle to work out the pose, I lightly sketched out the head and hand with a charcoal stick.

## Step 2

I switched to my charcoal pencil, which I kept sharp at all times, and started adding detail to the eyes, putting in the dark of the pupils and leaving the white of the paper as the highlights. Next I drew in the outlines of the mouth, nose and chin. Using the side of the charcoal stick, I added tone on the cheeks, nose and side of the head. With a tortillon, I spread and softened the tone until it was blended in and the face was beginning to look more three-dimensional.

## Step 3

I went over the drawing with the charcoal stick to build up deeper, darker tones then, using the tortillon, I blended the tones together. I drew lines on the hand with the charcoal pencil before adding tone to the fingers and back of the hand with the charcoal stick and tortillon. I used the putty rubber to lift some highlights out around the nose, chin and eye area.

## Step 4

After stepping back and taking a long look at the drawing, I realized I had failed to see that the space between the nose and the top lip was far too big. I set to work with the putty rubber, erasing the mouth, redrawing it and moving it further up. Then I added tone and blended it in. Using the sharp charcoal pencil,

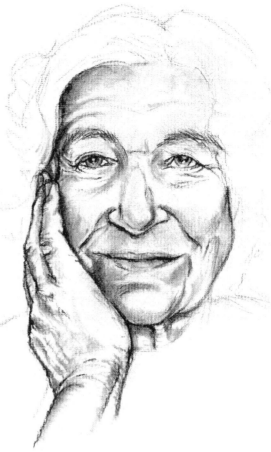

I tightened up the darker lines at the edges of the lips. With a grey compressed charcoal stick, I quickly applied tone to the hair, keeping it light so that it would frame the face but not overpower it. I used a paler grey stick to add lighter areas. Then I went back to the charcoal pencil and added some fine lines of detail for the shadow areas next to the eye, hand and cheek on the other side of the face. A few dark lines gave the idea of shadow in the hair. I added the shadow of her hand on her sweater, along with a suggestion of a casual neckline. Finally I used my putty rubber to lift out more highlights in the eyes, the lower lids, and the creases around the eyes, lips and chin.

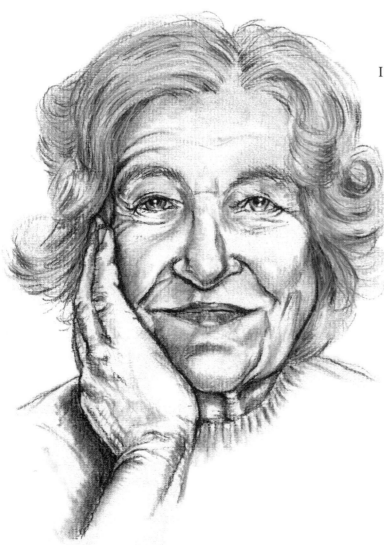

## Body Basics

As you progress on your journey as an artist, it's important to gain some knowledge of anatomy. The human body is a complex and wonderful structure, but for the drawings in this book I'm going to keep things as simple as possible. When you feel you want to tackle more advanced anatomy, there are many good books which deal in depth with the skeleton and musculature. But starting with the basics will help build your confidence.

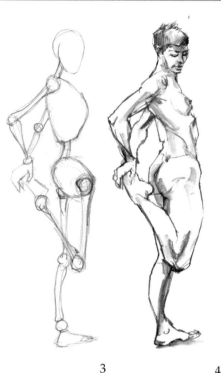

1

2

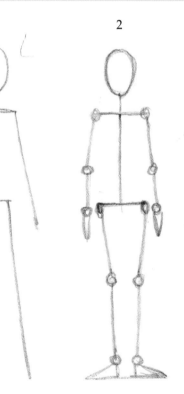

3

4

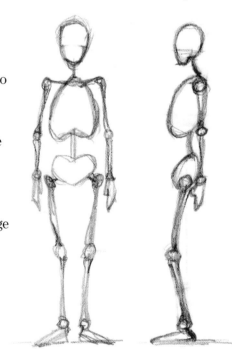

3. Then I added a ribcage and pelvis to give some solidity to the torso.

4. Finally, I arched the spine and, where it connects to the skull, sloped it forwards. I made sure the ribcage and pelvis tilted forwards slightly. I now had a fairly realistic and poseable figure.

1. Everyone can draw stick figures. All I've added here is a line for the shoulders and for the hips.

2. Next I put in some joints as hinges for the arms, elbows, wrists, hips, knees and ankles.

This is a simple but effective way of drawing the human body. Practising your stick figures will help immensely when you come to draw from life or photographic reference. Try to get into the habit of seeing these shapes when you look at people, as this will give you a better understanding of the body.

Shown here are some examples of
life drawings and their stick figure
counterparts.

# Standing figure

The challenge here was to draw an inexperienced model. I used a brush pen as I had to work quickly before the model moved. This enabled me to draw and add the wash faster than most other media.

**MATERIALS AND EQUIPMENT**

2B pencil
Brush pen
No. 8 round watercolour brush
130gsm (80lb) cartridge paper
Tissues

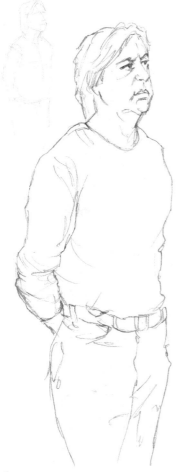

## Step 1

After a first doodle to get the pose and loosen up, I moved on to sketching the figure using a 2B pencil. I kept the drawing loose and almost entirely linear, as I would be adding the detail and tone with the wash.

## Step 2

I switched to my brush pen and started to ink in my drawing, again keeping the line work to a minimum. Once I had finished inking in the figure, I erased all the pencil lines.

## Step 3

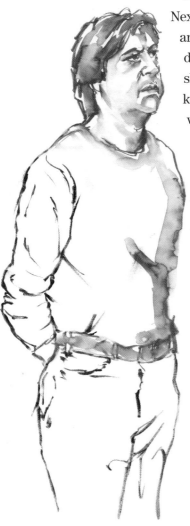

Next I loaded the brush with water, shook it slightly and began to wash in tone. e and create a lovely dark tonal wash. I left the white of the paper to shine through for the highlights in the hair and kept some tissues handy to mop up any excess water. I used a damp brush around the eyes, as I didn't want this area to become too dark, then dragged another loaded brush down the side of the cheek and softened it with some tissue. While my work was drying, I used a wet brush down the side of the chest and belt and let the water do what it does best. When you use this medium you always get what are known as 'happy accidents', where the ink and water make their own patterns. Once it had dried, I spent time going back over any areas of the face that were too light.

## Step 4

I started quickly washing in the rest of the figure and accidentally made a puddle of water at the side of the arm. I lifted some of it off and made a mental note to go back to it once it was dry. I finished with the jeans, taking care to stop before I added too much detail – I wanted this to be a loose wash drawing. Once it was dry, I took another look at the arm but decided to leave it as it was, since it seemed to fit with the rest of the sketch. I touched up the eyes and eyebrows, and then I was finished.

**TIP**
Always make sure your ink drawing is dry before erasing your pencil lines, otherwise you will end up with a smudged drawing.

# Teenage blues

Here I tried to capture that tricky time in life when you go from being carefree child to moody teenager with the weight of the world on your shoulders. The addition of the party hat prop helps to convey the changes taking place in the young man.

## Step 1

First I sketched a stick figure to get the feel of the leaning pose. Then I drew the pose as accurately as possible using the Derwent watersoluble pencil. I kept the pressure on the pencil fairly light, increasing it only in certain areas where I wanted the tone to be really dark when I added the water.

**MATERIALS AND EQUIPMENT**

Derwent Medium Wash 4B watersoluble pencil
No. 6 round watercolour brush
Putty rubber

## Step 2

Stepping back from the drawing, I could see that the subject's head was too small at the back and the side of his face and his hands needed adjusting. I consulted the reference photo to fix those. Next I darkened some of the folds of the T-shirt, especially around the armpits – it was important to get this right in order to create the illusion of him leaning forward. I started to refine the face and add more detail to the hair.

## Step 3

I went over the whole drawing with a darker pencil tone so that when I added the water it would create a mid to dark wash. I added detail on the railing and then filled my brush with water. Washing in the water on the hair immediately gave me a rich, dark tone. I left the white of the paper for the highlights and carefully followed where the light fell and where the dark tones were.

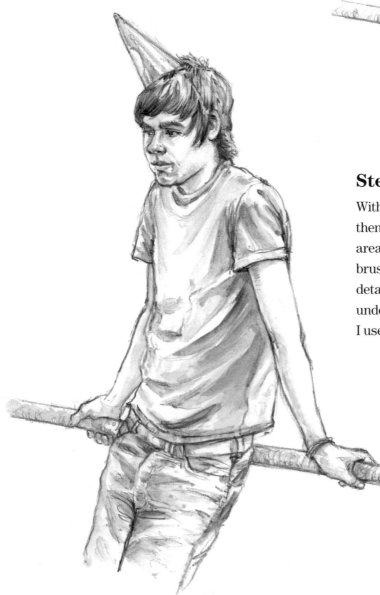

## Step 4

With most of the wash applied, I waited until it was dry then went back in with a sharp pencil and darkened any areas that had dried too light, before reapplying a damp brush to soften and blend them. I added some more detail to the hair and made sure it was slightly darker under the line of the elastic band of the hat. Finally I used the putty rubber to tidy up any smudge marks.

**TIP**

If you get a bit lost with your drawing it's best to stop, walk away and do something else. Make a cup of tea, go for a walk and chill out. When you get back you'll find you're refreshed and will know how to proceed.

# Summertime goth

I spotted this goth lady on a glorious sunny day at a country fair. She was dressed in black from head to toe, with a Victorian parasol and heart-shaped red sunglasses, and she was holding an ice-cream cone.

## MATERIALS AND EQUIPMENT

3B, 4B and 6B pencils
220gsm (100lb) smooth surface cartridge paper
Putty rubber

## Step 1

After a quick doodle I went straight to work with the 3B pencil, sketching loosely to get the proportions right. I made sure I had plenty of room on the page for my subject's shadow, to be added later.

## Step 2

Next I refined her figure and indicated the shadow under the chin, arm and leg areas with some vertical lines. I added in all the creases and folds elsewhere. Referring to the photo, I drew the detail on the face, bag and boots.

**TIP**

When you're trying to discover the darkest and lightest parts of your subject, look at it with half-closed eyes. This will help you to identify the tones more easily.

## Step 3

I switched to my 4B pencil and added dark tone to the hat, as this was all in shade. Then I added more vertical lines to suggest the black of her top. I used a 6B pencil for the shadow under the hat and elbow. I returned to the 3B for the shadow on the face and kept it light as I didn't want it to look dirty. I put in the outline of the shadow so that I would remember to add it later.

## Step 4

I used the 6B pencil for the really dark areas, 4B for the mid-tones and 3B for the rest. I tried to draw all the tone as vertical lines to keep the drawing consistent, but made an exception for the hair and umbrella, where I followed their contours. I finished by adding tone to the shadow, again using mostly vertical lines to suggest blades of grass. A shadow is darkest close to the object, and fades as it gets further away.

# Crossed-legs pose

I saw this guy sitting cross-legged on the grass at a party and thought the pose would be a good step-by-step exercise. He also has great dreadlocks to draw! I decided on pencils for a nice mixture of line and tone.

## Step 1

After my usual warm-up doodle, I worked up the main sketch using a 3B pencil. When you make a drawing, look for clues as to how you can show the proportions and pose accurately. One trick is to draw the negative spaces – the shapes between the solid forms. You can see these below as white areas in the grey image. In this case, they help you to find the position of the waist, the correct angle of the bent legs and the point where the arms fall across the knees.

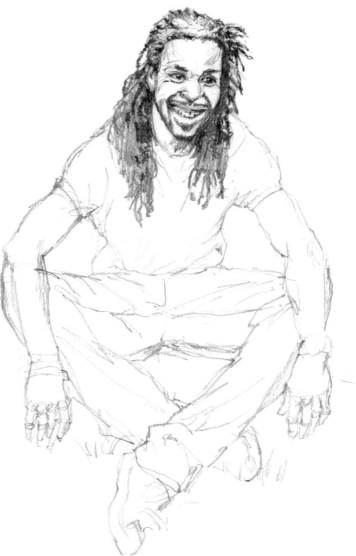

## Step 2

Moving on, I started adding details to the face and hair. On the latter I used the 3B pencil to lay down the mid-tone then drew on top with the 4B for the dark tone, making sure I left some of the lighter tone visible. The top of the head had more light on it, so I left the white of the paper as highlights. I kept the face fairly light, adding tone only where it was needed to indicate some shadow.

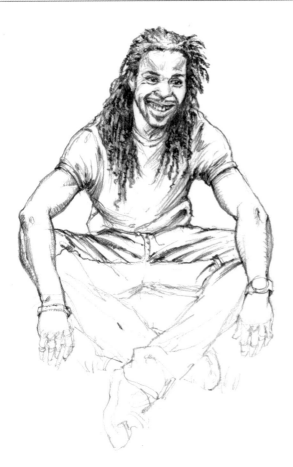

## Step 3

I finished the hair and worked my way down, starting with the T-shirt. I made sure the folds followed the contours of the arms, going around and down, and suggested the recession of the upper torso with a few lines meeting the fold in the T-shirt. I used contour lines again for the arms. Notice how the forearms are pushed forwards, making them appear larger than normal.

## Step 4

I rendered the rest of the drawing as usual, the hands first, then the creases in the jeans, again just following the direction of the folds and shadows. I finished with the shoes and a suggestion of the grass – there was no need to draw every blade, just enough to indicate where he was sitting. I added his beer bottle and used the putty rubber to draw in some blades of grass in the tone on the trousers.

**TIP**

To save time when you're drawing, it's worth having a variety of sharpened pencils so that you can continue drawing when the one you are using becomes blunt.

# Bangles

I took a photo of this lovely girl at an Indian dance festival. I was looking forward to doing a charcoal drawing to capture her beautiful skin tones and the shimmer of her outfit.

**MATERIALS AND EQUIPMENT**

Medium willow charcoal sticks
Derwent dark charcoal pencil
220gsm (100lb) smooth surface cartridge paper
Putty rubber
Tortillons or stumps
Sharpener or craft knife

## Step 1

I started sketching quickly with a charcoal pencil, checking the reference photo as I worked. The drawing seemed to flow with this one and I completed it quickly – sometimes you'll find that a drawing seems to happen almost magically before your eyes, but other times it seems like a bit of a struggle. It's all about trying to relax and enjoy what you're doing.

## Step 2

I started on the head, using the charcoal pencil for all the fine details such as the eyes, keeping my pencil sharp. Once I had drawn the face, nose and mouth I switched to a charcoal stick and, breaking off a small piece, used the side to add tone to the face. I softened and blended this with a tortillon, then used the point of the tortillon to draw a suggestion of the teeth – a hint of them was all that was needed. For the dark hair, I continued with the charcoal stick. I used the putty rubber to lift out some highlights and put in the fine lines and jewellery with the charcoal pencil.

## Step 3

Next I began on the folds and patterns, using the pencil for details and a stick for tone. Where the cloth was in shadow, I added the tone and used the tortillon to soften and shape. I paid close attention to where the light fell, and left crisp white paper for the highlights or used a putty rubber to lift them out afterwards.

**TIP**

When you finish a charcoal drawing you can spray it with fixative (available in any art store) to stop it smudging. This is best done outside, as fixative is toxic if inhaled.

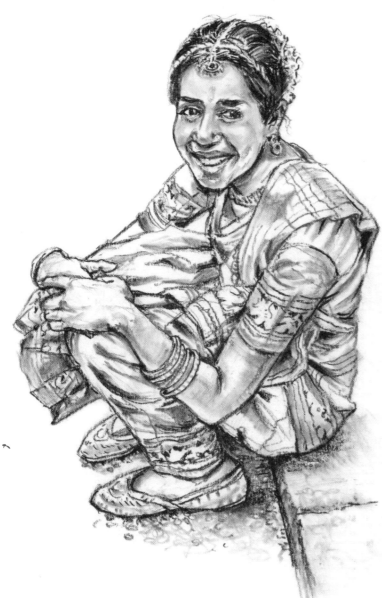

## Step 4

I continued to work on the tone and detail as before. Finally I used a sharp charcoal pencil to tighten up the drawing and add detail to the bangles, clothes and shoes. If you look closely you'll see that the detail is only suggested with a few squiggles or lines here and there – just enough to give the impression of detail.

# Taking a break

This drawing of my mother was done from a photo taken on a sunny day, so I used pencils to keep the image stark and create the feeling of strong sunlight.

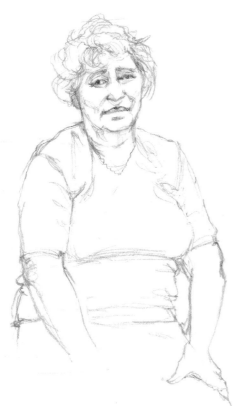

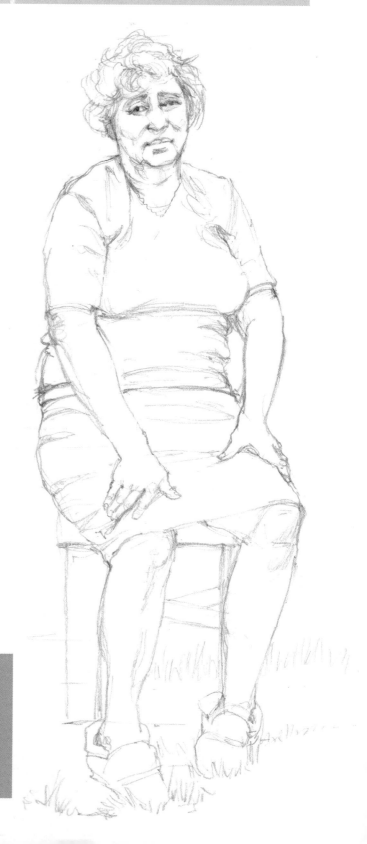

## Step 1

Using a 3B pencil, I started sketching out the figure. I tried to capture the slightly sad expression in the eyes and arched the eyebrows upwards, which helped to emphasize this.

## Step 2

Next I redrew the mouth and finished the rest of the figure. At this point I was just indicating lines for where the tone would go.

**TIP**

Before you start a drawing, do some warm-up exercises. Start with doodles of whatever comes into your head just to relax your hand, then do a rough sketch of what you're about to draw. You can work from this as you begin your finished drawing.

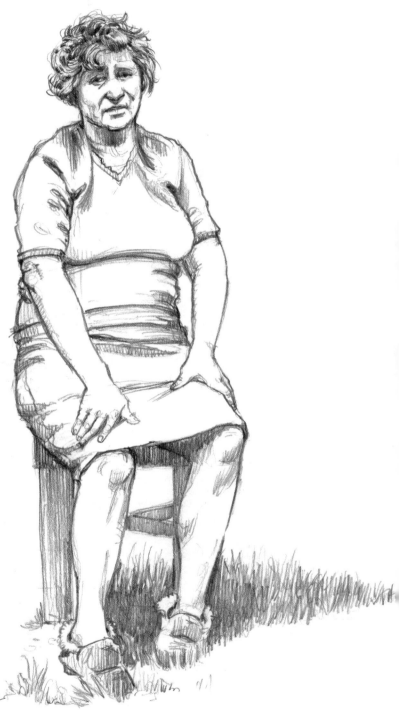

## Step 3

Turning to the 4B pencil for all the darker tone, I worked first on the face, eyes and mouth. I reverted to the 3B for the shadow on the forehead, then switched to the 4B for the rest of the drawing. Moving down the body, I laid down darker tone for the shadows and lighter touches for the mid-tones. As the light is from above and to the left, the darkest tones are mostly on the face, shoulders and beneath the chair.

## Step 4

I kept the tone on the legs to a minimum to suggest the starkness of the light. To separate the chair from the figure, I used vertical lines for the tone. I created the shadow under the chair as blades of grass to establish a location. Finally I returned to the head and, using a putty rubber, lifted off some highlights in the hair before cleaning up stray lines and marks on the face and around the figure.

## Drawing the Ordinary

A drawing of virtually any object that doesn't move can be classed as a still life, be it a bowl of fruit or a parked car. The classical artists all used to sketch everyday domestic subjects such as fruit, flowers, bottles of wine, cheese and bread. As an artist, it's important to pay attention to the small details that make up the larger aspects of life.

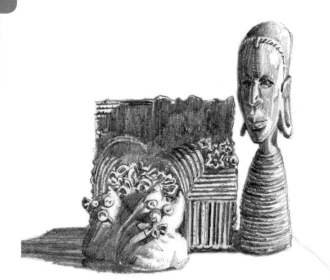

Drawing a still life is a question of trying to capture on paper the shapes and relationships between the objects in your composition. The three decisions you need to make before you start drawing are: What kind of objects are you going to choose? How will you arrange them? And, most importantly, how will you light them? Don't rush this process – take time to arrange your composition, looking at it from all angles and experimenting with the angle of your light source. Alternatively, just use natural light streaming in from the nearest window, positioning your objects to make the most of the interplay of light and shade.

Over the next few pages I use different techniques and materials to create still life drawings, some of classic subjects, others of more modern themes.

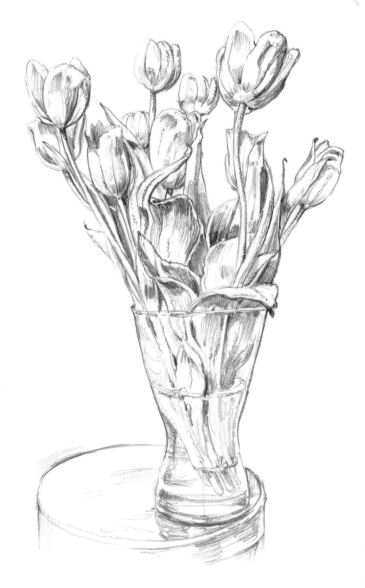

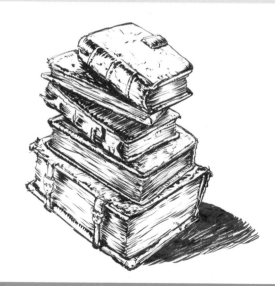

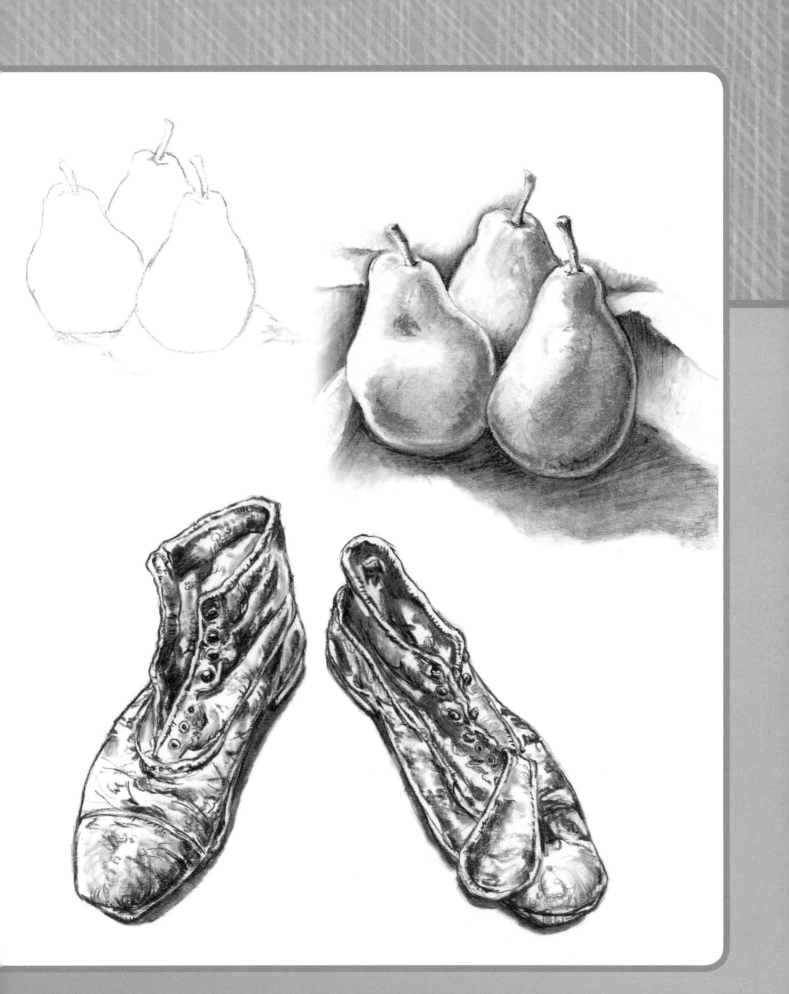

# Bowl of fruit

When setting up a still life, try to include objects of various heights and shapes to make your picture more interesting, and think of your background as part of the composition. I rearranged our fruit bowl so that I had different shapes to play with. I added a white sheet as my background and made sure it had some folds and creases to make the drawing more challenging. With natural light coming over my right shoulder, I placed an anglepoise lamp to the left and above to create some pleasing shadows on the fruit and folds of the cloth.

**MATERIALS AND EQUIPMENT**
Medium willow charcoal sticks
Derwent dark charcoal pencil
130gsm (80lb) cartridge paper
Putty rubber
Tortillons or paper stumps
Sharp craft knife
Sandpaper

## Step 1

I loosely sketched out the composition with a stick of charcoal, breaking the stick to get a sharp point to draw with.

## Step 2

With the side of the charcoal, I started putting in the mid-tones and smudged them with my finger, leaving the white of the paper for the highlights. Don't worry if you go over the white areas – you can lift them out later with the putty rubber. Then I shaded in the dark areas, using the charcoal and smudging it with my finger and a tortillon. I added some shadows on the sheet to show a surface beneath the bowl.

## Step 3

With the drawing well established, I started to build up the tone further. I used the putty rubber to draw in the side highlight on the apple, added a darker line to the stalk, then, using the tortillon, pulled some of the black tone down from the top of the apple. I worked my way round all of the fruit, adjusting the tones and using the tortillon like a pencil to create the texture of the skins, applying circular motions for a pitted look. On the lemon, I used the side of the tortillon to soften the highlight and dark tone. I added the dark shadows all round and used the same techniques to give a nice finish to the fruit.

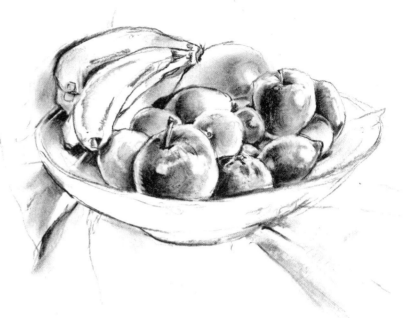

## Step 4

I did further work on the bananas and avocado at the back and gave them more shape and form. I used the side of the tortillon to get that sectional effect on the bananas and, once I had darkened the tone on the avocado, applied the tortillon like a pencil to give some texture to the skin. I added dark tone to the side of the bowl in the foreground and used the tortillon to blend the tones and create texture. I did the folds of the sheet in the same way. The darkest values were in the area where the bowl meets the sheet; to show these I used the charcoal pencil with a freshly sharpened point to draw in dark lines under the bowl and outwards. I then applied the smudge tool on its side, working upwards and outwards to produce what look like faint pencil lines. Using the charcoal stick, I added dark tone behind the bananas and blended it. Finally, I reinforced some of the darker lines on the fruit and bowl with the point of the charcoal pencil, then used the putty rubber to restore highlights that had been smudged.

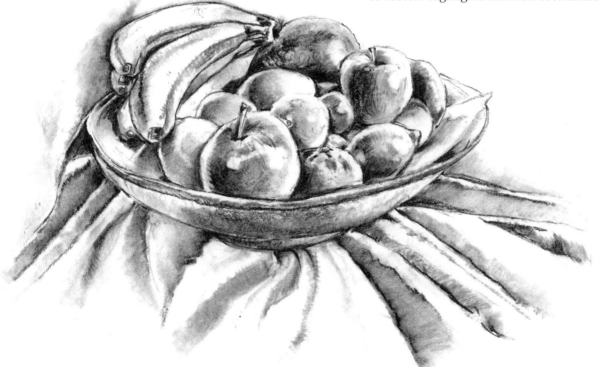

# Tulips

When tackling multiple objects in a composition it can be hard to know where to start, so try looking carefully for relationships between the shapes. With these tulips, if you follow the line of a stalk as you draw it, you will see it cross over another stalk or petal in the vase. This will give you a point of reference so you can follow this other stalk or petal to create an accurate drawing. Look for negative spaces, as drawing these will help you piece things together.

## MATERIALS AND EQUIPMENT

3B and 4B pencils
220gsm (100lb) smooth surface cartridge paper
Putty rubber

## Step 1

I took these tulips outside into the sun to make a still-life drawing of them. Using a 3B pencil, I drew in one of the flowers at the top left to get me started. Then I drew some negative spaces between the flowers and sketched in the jar to hold everything together.

*Negative space*

**How to draw a vase**

Top

Centre line

Bottom

## Step 2

I continued to outline the flowers and leaves which fill the middle of the vase and then sketched in the little reflective tabletop. Here and there I suggested where some tone might go in later.

## Step 3

Once I had everything sketched in, I started at top left again and worked down and across, adding detail and shadows. As always, I left the white of the paper for the highlights. I suggested the texture of the flowers by using pencil lines to create the contours in the petals. I then started to establish all the dark areas of tone in between, using a 4B pencil.

*Negative space*

## Step 4

Trying to keep the drawing crisp and clean, I used a 3B pencil to draw the image in the water – I wanted this to look lighter than the stems and leaves above the vase. I outlined the vase and added more tone to the water. Finally, I added tone to the table to make it more solid.

# Boots

If your still-life subject is a well-used item it can introduce a narrative element, prompting the viewer to think about its history. These battered boots had been worn in a London theatre production of Samuel Beckett's *Waiting for Godot*.

## MATERIALS AND EQUIPMENT

Medium willow charcoal sticks
Derwent dark charcoal pencil
130gsm (80lb) cartridge paper
Putty rubber
Tortillons or paper stumps
Sharp craft knife

## Step 1

I was going to make this a pencil drawing, but after I made the loose initial pencil sketch to get the general shape of the boots I did a charcoal doodle and liked it, so I decided to go ahead with charcoal instead. It pays to keep your options open and take advantage of what works, rather than sticking doggedly to your original plan. So why not start your sketch with the charcoal stick?

## Step 2

I broke off half a stick of charcoal and, using the sharp end, proceeded to add the details of the boot, buttons and stitching. Next, with the side of the stick, I added the dark creases and mid-tones in the interior of the boot, then used a tortillon to blend the tones and soften any edges that had become too dark.

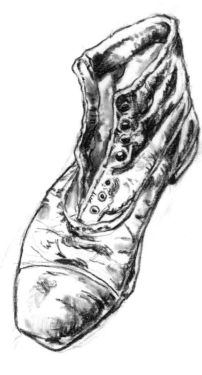

## Step 3

I continued to work on one of the boots, adding tone and detail, as I was keen to see how it would look when finished. As I wanted the boots to look well-worn, I emphasized all the creases and scratches using the charcoal pencil for fine detail, the stick for broader work such as tone and the tortillon for blending.

## Step 4

After finishing the first boot, I set to work as before on the other one, drawing in all the detail of the buttons, eyelets, folds and creases and using the putty rubber to lift out any highlights or areas that had become too smudged. I like the way this boot looks as though it's collapsed in on itself – it appears tired and worn and even has its tongue sticking out! When I was happy with the distressed look I finished off with the shadow under the shoes, using the side of the stick.

# Old books

This is a simple still life you could easily set up at home. You may not have books as old or elaborately bound as these, but you probably have some favourites you could put together to make an interesting overall shape.

## Step 1

I decided to jump right in and start drawing with the brush pen, but you might prefer to make your first sketch in pencil. I kept the initial sketch to a basic outline, starting at the top and working my way down.

As these were old books, the pages were not always straight or perfect and I paid close attention to all the tears and scratches so I could add more detail to them later.

## Step 2

Once the outlines were in place I decided that I would complete the books one by one and then go back to add more detail as required. I kept the top of the first book fairly sparse in detail, adding only the cracks and tears at the edges. Using a brush pen was great because I could alter the weight to give fine lines for the pages and heavy lines for the shadows and damaged spine. I added some shadow under the book to ground it on the one beneath.

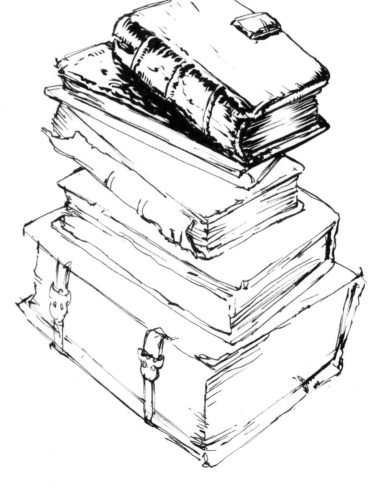

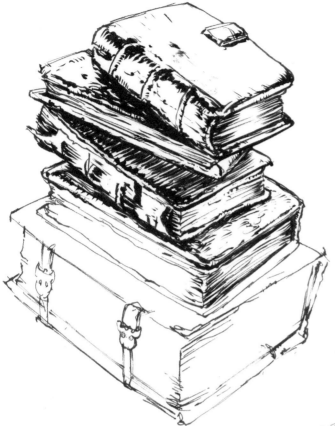

## Step 3

I finished the second book, keeping it simple and adding some heavier lines at the bottom. I worked fairly fast on the third book, laying dark lines for the colour and shadow. The spine was falling apart, so I suggested this with a series of lines. Putting dark shadow under the edge of the back cover created the illusion that this book was resting on the next, then I worked on adding some distressed lines here and there. Again I used heavy lines to suggest shadow and finer lines for the pages and details, such as the clasps at the bottom. I made sure that some of the pages looked buckled by giving them a slightly wavy line. Next, I drew darker lines round the edges of the cover of the fourth book and some darker splodges to ground it on top of the last book.

## Step 4

I wanted the last book to look big and sturdy, so I darkened the edges of the pages closest to me. I drew the clasps with the finest line possible and added their shadows – not as a solid, but as though the shadow were bleeding along the edge of most of the pages, leaving the occasional line clear. I finished by putting in a solid shadow on the surface of the table, breaking up as it stretched out to help ground the whole drawing.

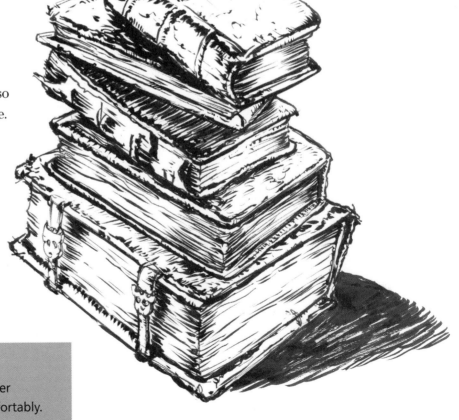

**TIP**

Don't be afraid to move your sheet of paper around if it allows you to draw more comfortably. This will help you when drawing lines of any angle.

# Three pears

This is a simple triangular composition with some cloth arranged behind it. The light source is from above and off to the left.

**MATERIALS AND EQUIPMENT**

Dark grey pastel stick
Medium willow charcoal sticks
Derwent dark charcoal pencil
130gsm (80lb) cartridge paper
Putty rubber
Tortillons or paper stumps
Sharp craft knife

## Step 1

Using the pastel stick, I quickly drew the outline shape of the three pears and added a hint of the cloth. At this stage I just wanted to establish big shapes.

## Step 2

I added tone to the dark side of the left-hand pear and smudged it around the form of the pear using my finger, leaving the white of the paper as highlights. I darkened the inner edge of the pear and the stalk, which were furthest away from the light. With the putty rubber, I lifted some reflected light at the bottom of the pear. The pear was coming to life already, with just a few simple strokes.

## Step 3

I repeated the process with the other pears and began to suggest the darker tones, blending them in with the side of the tortillon for broader strokes and the point for finer lines. I darkened the stalks and added some lines for texture. I left white highlights at the top of the fruit to suggest the light bouncing off the curves and dips.

## Step 4

Now it was time to use the charcoal sticks and pencil. I drew in the cloth behind and at the side of the fruit using the point of the stick. Then I drew heavy lines round the fruit where the dark tone would appear on the folds. At the top I used the tortillon to blend this up and out. I repeated this at the sides, making sure the areas close to the fruit were dark and graduated outwards. I used the stick to add the darkest tone at the side of the

pears, then blended this in towards the middle of the fruit using the tortillon. Next I added the dark shadow under the fruit and blended it outwards.

Finally, I sharpened some of the edges, the stalks and some of the sides of the pears with the charcoal pencil. I noticed a dent on the left-hand pear and added a darker smudge here to indicate this.

# Pillow talk

Elaborate props and complicated composition aren't necessary for a good still life. Here the pillows are simply arranged on the bed, with rumpled sheets giving some interesting folds.

## Step 1

Using the watersoluble pencil, I set to work on the basic composition. As usual I looked for visual clues to help me draw accurately, noting where lines crossed and negative shapes occurred.

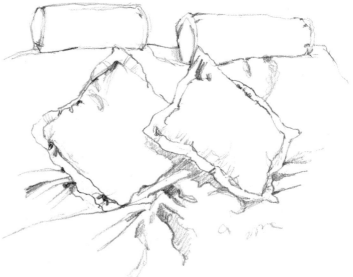

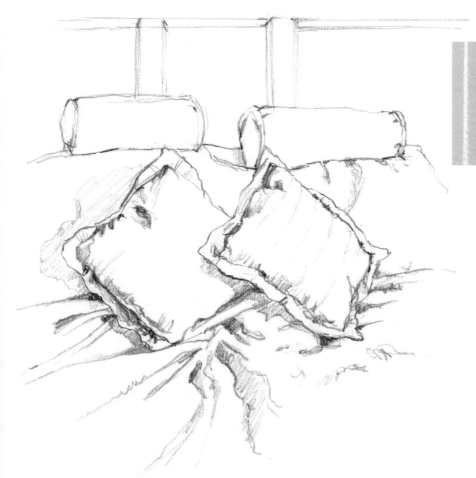

**MATERIALS AND EQUIPMENT**

Derwent Medium Wash 4B watersoluble pencil
No. 6 round watercolour brush
Putty rubber
Tissues

## Step 2

Noting that the light was coming through a window to the right, I added more detail, putting shadows round the pillows and the back of the headboard and indicating the pattern on the pillow. I darkened some of the drawn lines here and there.

## Step 3

Next I worked on the wood grain of the headboard. It's important to look closely at wood grain to draw it convincingly because it doesn't just follow straight lines, it curves, especially where there are knots in the wood. Here I merely suggested the grain, otherwise the background would have stood out more than the foreground.

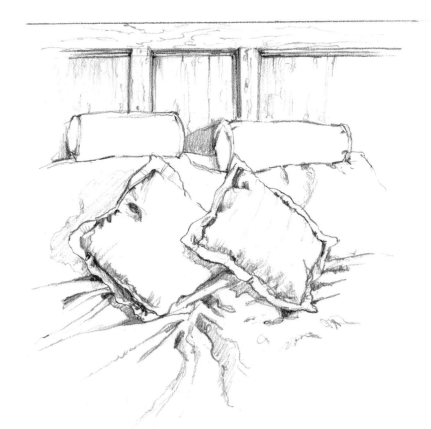

## Step 4

I loaded my brush with water and started to wash in the dark tone, keeping a tissue to hand for mopping up any overspills. I started on the shadows and let the brush do the work for me, softly blending the shadows over the bedspread. I softened the dark lines of the pillows, created a nice mid-tone shadow, then washed tone over the pillows to make a linear pattern. I worked all over the drawing in this way, then went back to the little folds in the pillow edges and softened the dark pencil slightly, leaving the white of the paper to give a little sparkle. I rubbed some dark pencil lines on a separate sheet of paper and, with a wet brush, lifted off some tone to paint in the little flower patterns on the bedspread. Once the drawing was dry, I took the sharpened watersoluble pencil and reinforced areas that had become too pale from the wash.

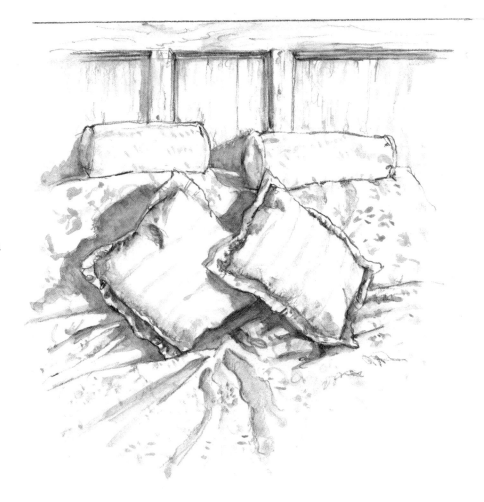

# African head

This again is a simple composition, using objects from around my house – a carved wooden African head, an Indian printing block and my daughter's tiny beanbag cats. I set them up in a pleasing group and lit it from the right-hand side.

**MATERIALS AND EQUIPMENT**

3B and 5B pencils
220gsm (100lb) cartridge paper
Putty rubber

## Step 1

I set to work using a 3B pencil, roughly sketching out the composition. I added the line of the table as a method of leading the eye into the picture.

## Step 2

Still using the 3B pencil, I started adding the detail in the cats, suggesting where the shadows fell. I moved on to the printing block and worked on the pattern where it would not be obscured by shadow. I drew in the line of shadow on the block, so that I knew where the detail stopped, and then turned my attention to the head. I took time to establish the dark and mid-tones round the side of the face, using the 5B for the dark areas and 3B for the mid-tones under the eyes and on the cheek and lips.

## Step 3

Next I worked on all the dark shadows using the 5B pencil, letting the white of the paper shine through for the highlights. With all the main shadows in, I began work on the circular carving beneath the African head. I carefully drew in the curves with the 3B pencil and, when I was happy with these, I took the 5B and added in the darker shadow where the light disappears under the cut of the wood.

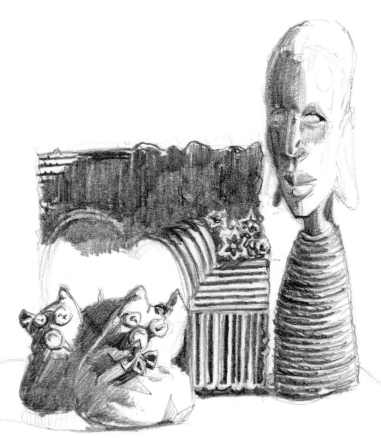

## Step 4

Now I spent time getting the shadows and pattern design behind the cats just right. Once I had done this I went back to the head and added the rest of the tone to the face. Although one side of the face is in almost total shadow, the areas round the eyes and nose are darker still, so I emphasized these and finished off by adding the shadows to the left of the drawing.

# Denim jacket

One of the advantages of still lifes is that they can be drawn inside or outside, depending on the weather. Here I took my wife's denim jacket and hung it on a coat-hanger outside our little shed in the garden so that I could enjoy the sun while I worked.

**MATERIALS AND EQUIPMENT**

Derwent Dark Wash 8B watersoluble pencil
No. 6 round watercolour brush
Putty rubber
Tissues

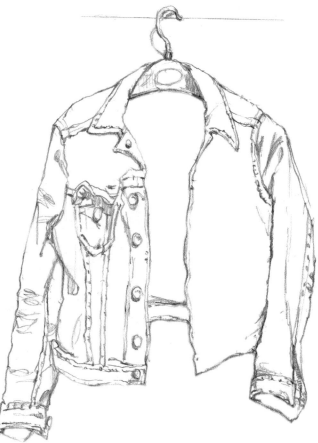

## Step 1

As this was going to be a wash drawing, I began by doing a fairly linear sketch of the jacket with the watersoluble pencil.

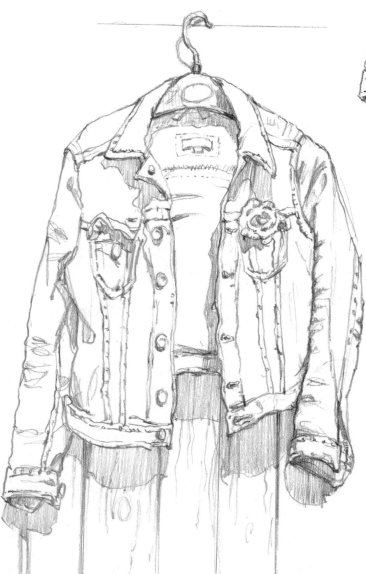

## Step 2

Once I had finished drawing the jacket I started to suggest where the shadows would fall by means of vertical lines, almost as if I were following the grain of the wood immediately beneath the jacket. I started to indicate the panels of wood behind the jacket.

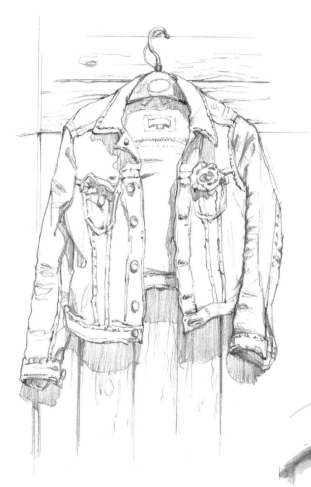

## Step 3

I wanted to suggest the rest of the shed before I added the final wash, so I started adding more panels and bringing out some of the detail of the grain of the wood. I kept this to a minimum though, as I didn't want the wood to dominate the drawing – it's purely a background element.

## Step 4

With all the tone and background I wanted now in place, I loaded my brush with water and softened the shadow lines into a rich, dark tone. I let the water work its magic, keeping a tissue to hand in case of overspills. Again, I didn't overload the drawing with detail – the wash suggests more than is actually there and helps to create the illusion that the jacket is hanging on the shed in the sun.

### TIP

If you're working outside on a sunny day, it's best to wear a cap or wide-brimmed hat to keep the sun out of your eyes and help you see your subject matter.

# Skull

I found this great image of a skull and decided to use the brush pen and a wash to help me capture the subtle differences in shade and texture.

**MATERIALS AND EQUIPMENT**

2B pencil
Brush pen
No. 6 round watercolour brush
220gsm (100lb) cartridge paper
Tissues

## Step 1

I made an initial doodle then, using my 2B pencil, I took some time to sketch the skull until I was happy with the way it looked. I added some tone here and there for shadows.

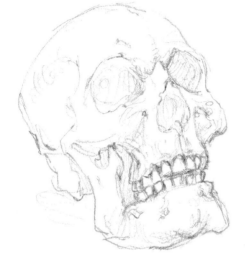

**TIP**

Before working with brush pens it's best to practise some quick little doodles. Draw some dark lines then, with your brush loaded with water, paint into the line and watch how the tone changes. The more water you add, the lighter the line becomes. Practise this a few times and you'll feel more confident when you come to the final drawing.

## Step 2

I went on to ink in the drawing using the brush pen, making my line thicker in certain areas where I expected to have more tone, as this would allow me a deeper tone when adding the water.

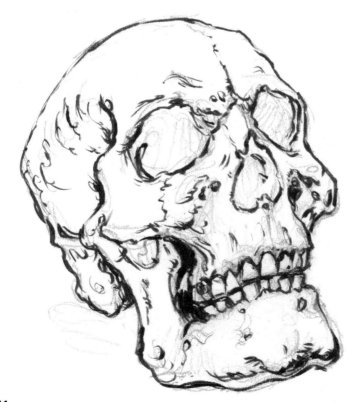

## Step 3

Loading my brush with water, I began to paint into the inked areas, initially at the back of the skull. I stopped to dab off some of the tone with a tissue, as it was getting too dark – you can always darken an area again later, but it's more difficult to lighten it once it's dried. I washed in the eye sockets and, while these dried, painted in the nose and cheek.

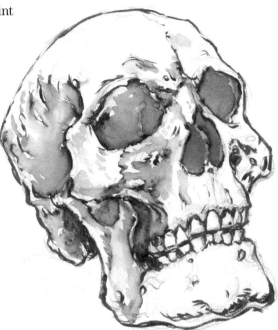

## Step 4

Working quickly now to avoid areas drying too fast, I painted in the whole skull. While it was drying I noticed that certain areas such as the eye sockets, the nose and the space between the jaw and the back of the head needed more tone to make them stand out. I swiftly added more black, first with the brush pen and then with the water-loaded brush. These areas dried a bit lighter than I wanted, so I quickly went over them again with the brush pen and used a slightly damp brush on top. This helped the drawing look more three-dimensional. Finally, I washed a shadow under the skull to ground it to the table.

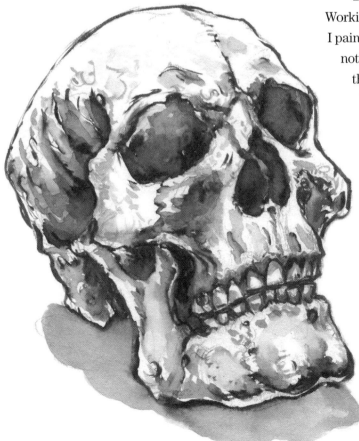

# Tomatoes and cucumber

Here's another simple still life that you can probably replicate from your own fridge – tomatoes and a cucumber – with different shapes and textures to make a good drawing challenge.

**MATERIALS AND EQUIPMENT**

3B and 4B pencil
220gsm (100lb) cartridge paper
Tortillons or paper stumps
Putty rubber

## Step 2

I added more detail to the stalks, then laid in the tone for the colour of the tomatoes, using the side of the pencil lead. Then, with the tortillon, I blended it to give subtle tone, creating the highlights by letting the white of the paper shine through. I switched to the 4B pencil and added the darker tone at the sides of the tomato. The wooden board was reflecting light back on the tomatoes, so I drew in a lighter edge in the dark tone with my putty rubber.

## Step 1

I arranged a simple composition of the tomatoes and cucumber on a breadboard and placed it by a window, letting the sun be my light source. Using a 3B pencil, I sketched out the scene.

## Step 3

I worked on the third tomato in the same way as before, using a 4B for the stalks and dark tone, 3B for mid-tones and the tortillon for blending. The tomatoes were now starting to come together, so I added the darker shadow between them.

## Step 4

I moved on to the cucumber and worked in much the same way, laying down a background tone for the colour, blending with a tortillon, adding the horizontal wobbly lines, then switching to the 4B for the darker lines and heavier shadow areas. I worked up the chopping board, adding mid-tones with the 3B and dark tone with the 4B. I added more grain and cracks to the board and blended them in. Finally, I added the last shadows to the tomatoes on the board and lifted some highlights on the stalks using the putty rubber.

# CHAPTER 5

## Looking Around

There is limitless beauty and variety in the world, but we are often so busy dealing with the events of daily life, large and small, that we forget to stop and just look around us. In this chapter you'll find a small choice of what's on offer in the natural landscape – but do take a break from your normal routine to find your own subjects. You'll find it's like turning on a switch and lighting up a darkened room as you discover more wonders, seeing them through the eyes of an artist.

The step-by-step demonstrations will help you understand how to render different aspects of the landscape, from country roads to snow-covered trees. When you try these exercises, use them as a guide to allow your individuality to shine and have fun drawing your own natural scenes.

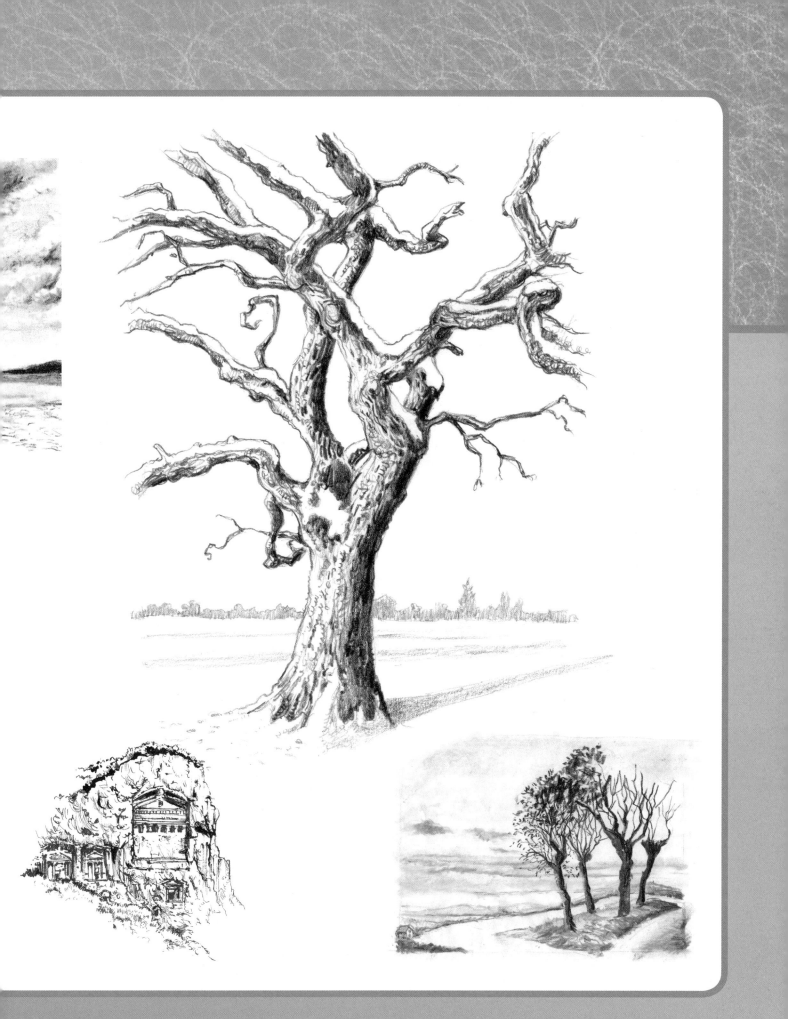

# Composition

Some novice artists find the subject of composition daunting, but all it means is the arrangement of the elements in a picture in an interesting and pleasing way. We use composition in our daily lives – for example, when we meet a group of people we focus on the person we feel we have most in common with and when we pull out our camera-phones to take a picture we make choices about how to arrange our subjects in a pleasing fashion. So maybe you already know more about composition than you think.

An easy way to help you compose a picture is to buy a small cardboard mount from your local art store. Hold this up to your subject and move it around until you find the ideal composition within the frame.

One of the main composition techniques employed by artists is something called the rule of thirds. I consider this more of a guide than a rule. First you divide your drawing into thirds with the help of two imaginary horizontal and two vertical lines. This gives you three rows, three columns and nine rectangles.

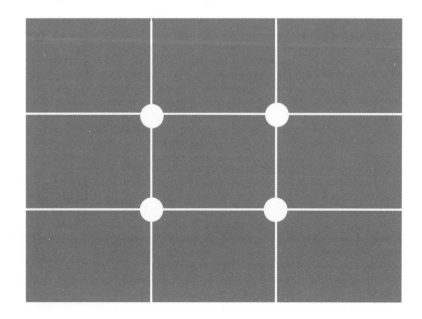

Anything important in the composition should be as close as possible to the lines or the point at which they cross. Basically, if you want to emphasize a beautiful sky then you need to keep your horizon line low – on or near the bottom line. To show a wonderful foreground, keep the horizon line high – close to or on the top line. The eye is drawn to where these lines cross, so anything important should fall near here.

Try to keep this guide in mind when you come to compose your picture. Eventually it will become second nature and you'll do it without thinking. Have a look at some paintings, drawings or photos and see if the artist has used the rule of thirds as a way to improve the composition of the artwork, then go off and apply this handy new tip to your own work.

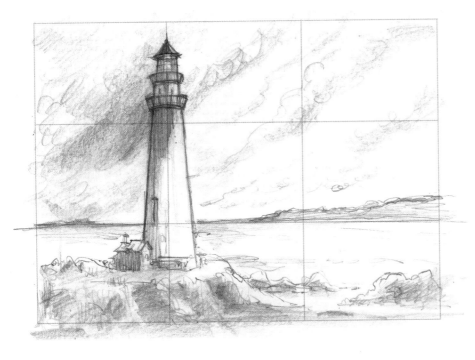

Here's an example using the grid. The lighthouse is prominent at the intersection points, the mountains cross the lines and the low horizon emphasizes the sky.

If you look at classical composition, you'll see that objects or subjects are arranged in particular shapes which help to lead the viewer's eye around the artwork to the focal points. The most popular of these is the triangular shape, though most geometric shapes can be employed. These shapes won't be visible in your final sketch, but using them will help you tell your story to the viewer.

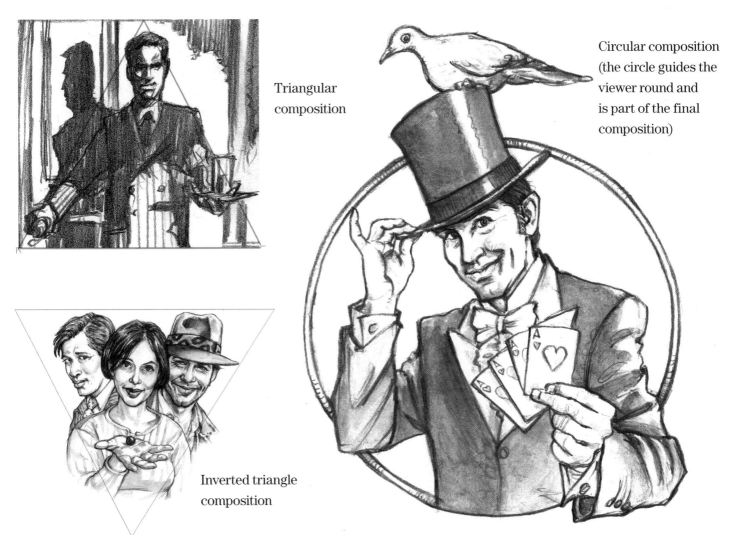

Triangular composition

Inverted triangle composition

Circular composition (the circle guides the viewer round and is part of the final composition)

# Perspective

We all understand from everyday experience that objects and figures look smaller the further away they are. To show this in your drawings you need to have a basic understanding of the rules of perspective; these will enable you to introduce a convincing sense of distance. There are three types of perspective – one-point, two-point and three-point.

## One-point perspective

This type of perspective comes into play when you are dealing with objects that face directly towards you. The simplest way to visualize it is to imagine a railway track in front of you, running towards the horizon; the track appears to become narrower as the rails converge in the distance. Of course, when objects with height, such as buildings, come into the picture, things get a little more complicated. However, there are two rules to help you: the first is that the horizon is always at your eye level; the second is that receding parallel lines converge to a single point on the horizon, known as the vanishing point.

## Two-point perspective

When you view a subject from an angle, there are two vanishing points on the horizon at which parallel lines converge, one on either side of the subject. They won't necessarily be the same distance from your subject – this will depend on your angle of view – but if you draw converging lines from the top and bottom of your first vertical lines, you will see how to construct your subject to make it look three-dimensional.

## Three-point perspective

The basic difference with three-point perspective, which is used to create dramatic or exaggerated drawings, is that there are three vanishing points. Two are along the horizon, but the third is located either above or below it. Place the third vanishing point so that it falls between the two horizon vanishing points, but as far from the horizon as possible. Draw lines to connect the three vanishing points – this will give you a triangle. To avoid distortion, it is important to keep your drawing within this triangle.

# Misty morning

This early-morning scene is created with pen and wash. I've used a permanent ink artists' sketching pen. This is a fine felt-tip pen which has the feel of a pencil, but the ink is permanent and won't fade no matter how many washes you paint over it. It is ideal for drawing a landscape like this, as the foreground is the sharpest focal point and everything behind it fades as it recedes. I used the pen for the silhouettes of the tree-line and painted in the washes for the background.

**MATERIALS AND EQUIPMENT**

3B pencil
Black artists' sketching pen or a permanent ink, black, fine felt-tip pen
Payne's Grey or black watercolour paint
220gsm (100lb) smooth cartridge paper
No. 8 round watercolour brush
Putty rubber

## Step 1

After a small doodle to work out how the scene would look, I made a quick pencil sketch of the mountains and the line of trees. There was no need to worry about details here; this was going to be a loose, light piece.

## Step 2

Next, using the pen, I started on the trees. First I drew vertical lines for the trunks all the way along, except for in the middle where I added some bushes for variety. Once I knew where my trees would go, I could draw in the branches and leaves, scribbling with the pen to create a tree shape – it was important not to do them all the same shape, as that wouldn't look natural. I left little gaps to suggest light coming through the leaves.

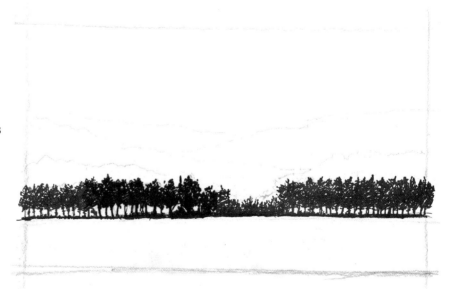

## Step 3

For the next stage you'll need to prop your drawing board at an angle so that the paint runs down the paper. First, to do the sky, I diluted some Payne's Grey paint in water, mixing a darker tone than I wanted for the end result. Starting at the top left, I brushed on the paint in one long horizontal stroke, right to the opposite edge. I then quickly cleaned my brush, loaded it with clean water and and dragged it across the paper, just catching the paint all the way along. You'll find the wash starts to do the work for you, pulling the tone down as you go. This will start to give you a graduation of the tone. Working quickly before the paint dried, I repeated this process of brushing on clean water until I reached the top of the first mountain range, which gave me a lovely graduated wash.

## Step 4

Once the sky was dry I moved on to the mountains and repeated the previous steps, using a darker tone for each one as I moved towards the foreground. As you will know, everything in a landscape becomes paler as it recedes into the distance, so the line of trees needed to be darker than the mountains. I dragged the wash down behind the trees and suggested a little lake with a pale wash behind the bushes. I repeated the same wash technique in front of the tree-line and into the field. Before that was dry, I added a wet shadow in the field, using a darker wash and painting in the graduation. Once everything was dry I added some more details to the trees with the pen to complete the piece.

# Snow tree

I've always loved this tree and when I saw it covered in snow I just had to draw it. It's amazing how the seasons change a simple scene; summer would see this tree blooming and full of colour, but winter gives us a bare, bleak picture. By focusing all the detail on the tree and keeping the rest of the drawing minimal, I could create the cold, stark feel of a winter's day.

**MATERIALS AND EQUIPMENT**

3B and 4B pencils
220gsm (100lb) cartridge paper
Putty rubber

## Step 1

First I drew a rectangle as a frame for my sketch to help me with the composition – I didn't want to include the entire tree or I would lose the feeling that it's bursting out of the frame. My intention was to keep this drawing very clean and simple, suggesting the starkness of a winter tree. Using my 3B pencil, I carefully outlined the tree and background.

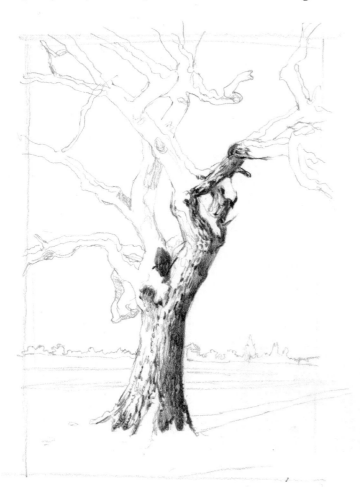

## Step 2

I put in all the dark shadow tone with the 4B pencil, then reverted to the 3B for the rest of the drawing. I suggested the texture of the bark using broken dark lines here and there, making sure I left plenty of lighter areas where the sun fell on the tree. As I worked my way up, I took care to leave the snow-covered areas clear of tone. Around the edges of the snow, I added darker shadow to help it stand out.

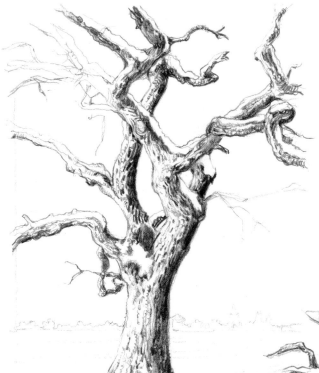

## Step 3

I worked fairly quickly, making sure all the pencil lines of the bark followed the contours of the tree as it twisted and… turned. I started to add numerous smaller branches, but decided to erase them as the drawing was starting to look too cluttered.

## Step 4

I finished the tree, leaving the white of the paper to show through to represent the white crispness of the snow. With the 3B, I drew the shadows, indentations in the snow and background landscape. I added some more shadow to the snow at the base of the tree, and in some other places on the tree where the branches reflected a darker tone on the snow. Finally, I erased all the pencil lines of the frame.

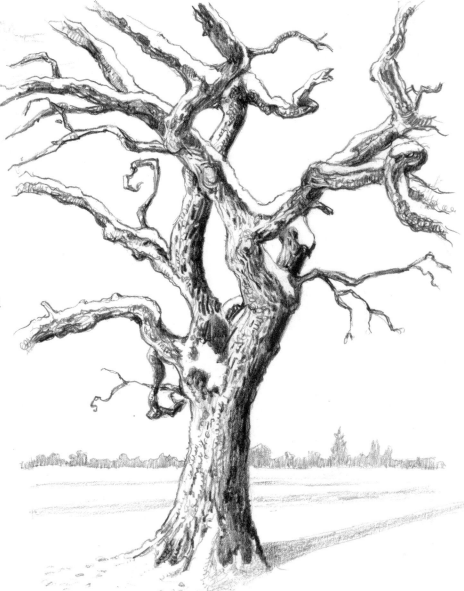

# Coast

This was a beautiful little spot I came across when I was out driving one morning in San Francisco. I've deliberately set the horizon line high up in the composition so the viewer's attention is drawn to the rocky coastline.

**MATERIALS AND EQUIPMENT**

Derwent Dark Wash 8B watersoluble pencil
220gsm (100lb) cartridge paper
No. 8 round watercolour brush
Putty rubber

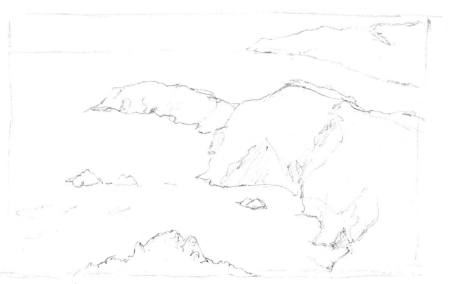

## Step 1

After a little doodle to establish the composition, I made a quick sketch of the rocky coast to get the bare details right. I kept the horizon line high so that the focus would be on the rocks.

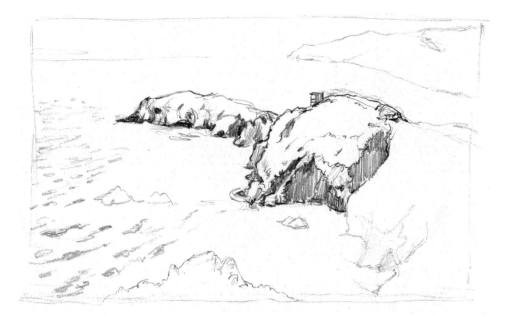

## Step 2

Next I went over the whole composition, adding more details and increasing the pressure on the pencil to ensure that the wash at the end would be satisfactorily dark.

## Step 3

I added the darker tone all round, and in the water I showed the shadow of the waves as they disappeared into the horizon. I started erasing the pencil lines around the little cabin on the rocks.

## Step 4

Loading the brush with water, I let it wash in the darker tones all over, starting with the rock mass and reloading with water to create paler washes towards the top. Then I dried my brush so that it was only partially damp and painted into the cave shadows and crevices; this helped to create some reflected light from the sea on the rocks. I was careful to leave plenty of light areas above and at the edges of the rocks, especially in the foreground. When that was all done,

I scrubbed the pencil on a separate sheet of paper to make a dark tone, then lifted the tone with a wet brush and painted into the ocean. I created some wave shapes then softened and blended them with a clean wet brush, leaving the white of the paper to shine through as though the sun were reflecting on the water. Finally, I washed into the rocks and put in more dark tone for the shadows, then added water to the pencil lines, washing them outwards to the horizon.

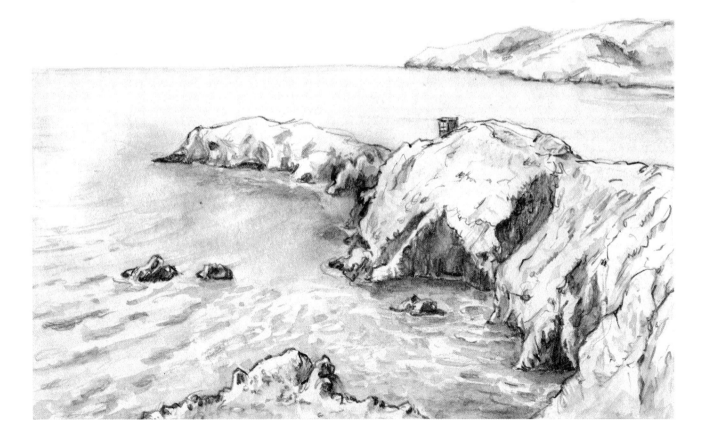

# Lycian rock tombs

I came across these tombs on a visit to Dalyan in Turkey. With pens of various sizes, you can draw a convincing rocky landscape using different weights of line to create the texture and tone that will bring the drawing to life. You can easily create more depth in your drawing by adding a foliage silhouette border to frame your picture.

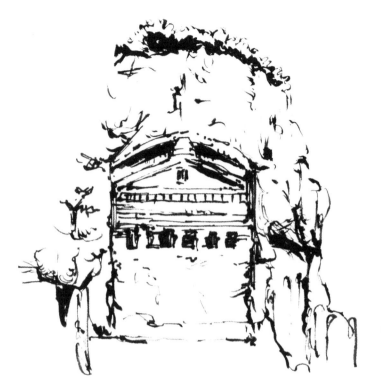

## MATERIALS AND EQUIPMENT

Brush pen
Black artists' sketching pen or a permanent ink, black, fine felt-tip pen
0.2mm drawing pen
130gsm (80lb) cartridge paper

## Step 1

I jumped right in with the brush pen, working very quickly at drawing the top of the rock face and the mouth of the first tomb.

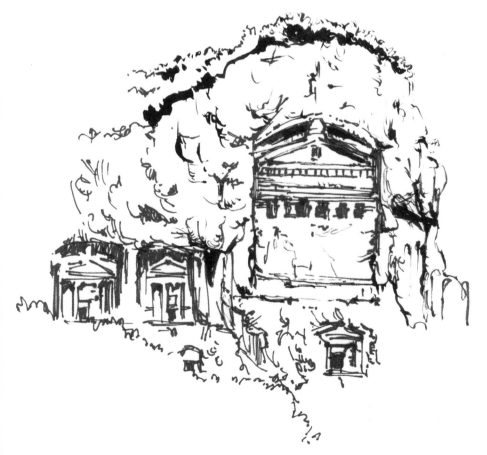
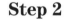

## Step 2

The next task was to start suggesting the rocks and fronts of the smaller tombs. These were all drawn in fairly big strokes, with detail to follow later. I put in the columns and little windows which have been hollowed out of the side of the rock.

## Step 3

I switched to the artist's sketching pen and tried to follow the contours of the cliff face, using finer lines for the small details and darker tones where the rock was hewn out to create the entrance to the tombs.

## Step 4

I picked up the drawing pen, which has a finer line than the artist's pen, and started on the foliage growing down the hill. When I had finished that, I added the shading on the tombs with tiny vertical lines. I switched between the pens to add more lines and create the ancient surface, then added more foliage on top of the mountain. I drew grass and rocks leading down the hill, fading these out. Finally, I framed the drawing with a solid black foliage canopy to give the feeling of a trek through the jungle being rewarded with a first sight of the tombs.

# Italian mountains

I found a wonderful photograph of the Dolomite mountains, which have been described as Italy's rocky rooftop. This is a simple example of how your tonal values work in a landscape painting. Keep in mind that your foreground is your darkest tone and has the most detail. In the middle of your composition you have your mid-tone and the details are beginning to fade. Further back is your lightest tone and the detail is almost non-existent.

**MATERIALS AND EQUIPMENT**

3B pencil
Brush pen
No. 6 round watercolour brush
220gsm (100lb) cartridge paper
Putty rubber
Tissues

## Step 1

Using my 3B pencil, I set to work drawing in the outline of the mountains, concentrating on the main shapes since I planned to use my brush pen next to outline everything and add the finer details.

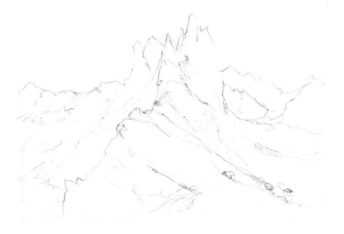

## Step 2

I inked in the top of the mountains with the brush pen, then moved on to the foreground mountain slope. I added the darkest tone to the left of the mountain, since the sun was over to the right, using the brush pen to create a suggestion of rocks. I put more rock shapes and crevices down the steep side of the mountain and drew in the tiny houses on the flatter slope to give some idea of scale. Then I loaded a clean brush with water and dripped it into the dark ink, using the brush to draw the rest of the rock details. The water created a lighter tone, giving a beautifully blended wash. I took care not to wash all the dark tone away and used a tissue to lift any pools of water that appeared.

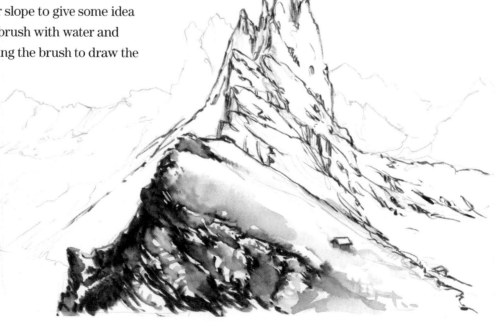

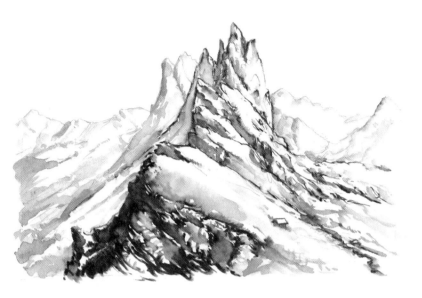

## Step 3

Once I had added the darkest tone in the picture, I needed to use a lighter wash for the background. With the edge of the brush pen, I painted some dark ink on the far side of the paper. Again using the brush loaded with water, I diluted the dark tone to a lighter mid-tone wash and painted this in the top and right-hand side of the mountain. I added more water to create a much lighter wash and used this to paint in the rest of the mountain backdrop, taking care to make sure the background receded by keeping it pale.

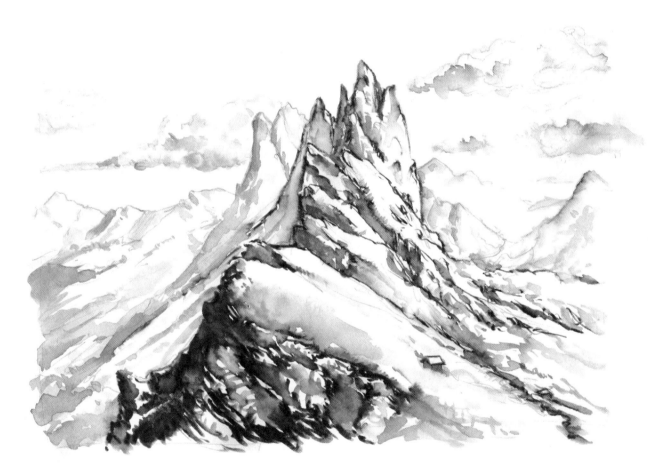

## Step 4

I added some small details to the foreground and darkened the little houses. I used a slightly darker mid-wash for some of the shadows here and there. To finish the piece, I added some clouds using the wash method described above. A mid-tone wash suggested puffy cumulus clouds; keeping the dark tone at the bottom of the clouds, I added a further wash of water to soften the effect.

# Seascape, Jury Bay

I didn't want to spend a lot of time on this drawing of a Scottish seascape because I wanted to keep it fresh and spontaneous, so charcoal was an ideal medium. As I drew, the wind was picking up and the light was starting to change – I needed to quickly block in the image before it changed too much.

**MATERIALS AND EQUIPMENT**

Medium willow charcoal sticks
220gsm (100lb) cartridge paper
Putty rubber
Tortillons or paper stumps

## Step 1

Using a charcoal stick, I drew a horizon line a third of the way down the page and added the dark shapes of the islands. Dividing the composition in this way immediately leads the viewer to focus on the sky. I used the side of the charcoal to suggest the clouds coming from the left and smudged these in with my finger.

## Step 2

I wanted a dramatic sky, so I extended the clouds across the page and darkened the undersides with the sharp end of the stick. Using the tortillon, I drew more cloud shapes and blended them. I used the side of the stick to add some tone to the water and blended again with the tortillon before suggesting the ripple of the incoming tide with the stick.

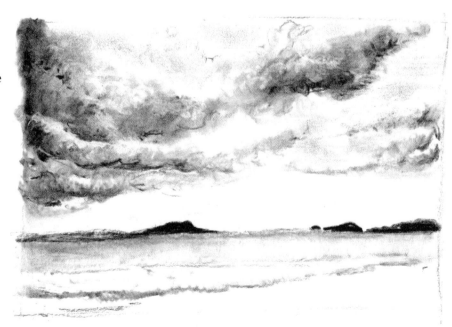

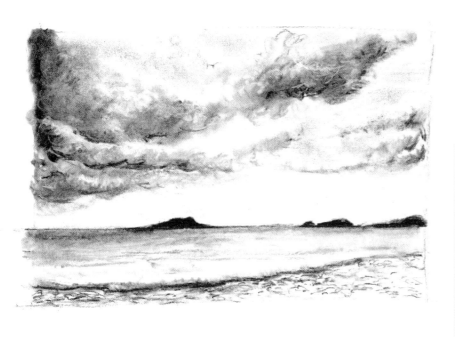

## Step 3

I added more lines to the waves and blended these in, then cleaned up the horizon on the left with a putty rubber and drew some loose detail on the shoreline.

> **TIP**
>
> Take your time working out your composition and deciding what your focal point should be. If you are drawing a dramatic sky, lower the horizon line; if you want the attention on the sea, then raise the horizon line. Doodle a few different versions to see what looks best.

## Step 4

After putting in some additional tone on the lower skyline and blending it in, I stepped back to have a look and decided that the drawing was completed.

I put a white mount around this quick little seascape to give it a crisp edge.

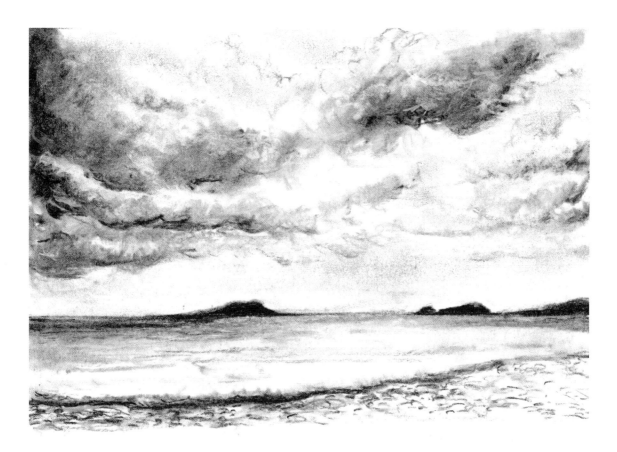

# Four trees

I was drawn to this composition because of the mass of trees that dominated the hill in the landscape, with four coming together almost like one giant tree erupting from the ground. It was a stark image that stood out for miles. Try half-closing your eyes when you look at your subject matter; this helps to break it into simple shapes.

**MATERIALS AND EQUIPMENT**
Derwent dark charcoal pencil
Medium willow charcoal sticks
220gsm (100lb) cartridge paper
Putty rubber
Tortillons or paper stumps

## Step 1

Using the pencil, I sketched in the scene, establishing the position of the trees, the background mountains and the road.

## Step 2

With the side of the charcoal stick, I started laying down the background and foreground tone. I darkened the grass verge in the foreground and around the base of the trees, then indicated some tone in the sky.

## Step 3

I added dark puffy clouds and a few lines of tone to suggest the fading sky and blended these in. I drew in the line of the mountains and the little house and softened them with the tortillon. I used the tip of the stick to draw in the dark tree trunks, then switched to the pencil to draw in the limbs and branches stretching out to the sky. With the tortillon, I softened the edges of the trunks, then loosely scrubbed in a suggestion of the grass below. With the same tools, I added more tone to the edge of the drawing to help frame the picture and give the idea of a road. Returning to the trees, I began to draw in the leaves using the tip of the charcoal stick, keeping this loose so that all you can see are dark splodges of foliage. I didn't want to draw intricate detail – from my viewpoint, splodges were what I could see. Beware of drawing what you think is there rather than what you actually see.

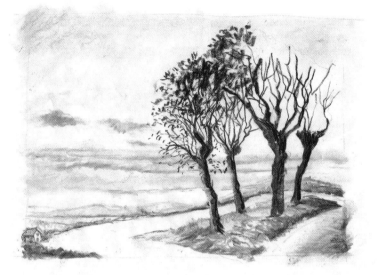

## Step 4

I covered the treetops with suggestions of leaves, alternating between the stick and the pencil and taking care to leave plenty of white paper showing through as the gaps in the leaves. Then I drew into the trunks with the tortillon to create some texture, and did the same with the road and grass, adding tone where needed. I suggested bushes and trees in the distance over to the left, and added some small leaves at the edge of the trees to finish.

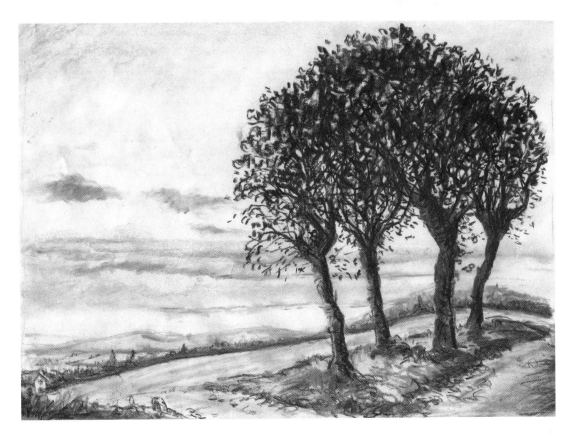

# Country road

Never settle on your first choice of view; it's always best to wander round to get the best composition. Think about what makes a good scene. Here I moved slightly off centre, letting the road guide me in. This gives the viewer the impression of travelling along the road towards the tree and the little house in the distance.

**MATERIALS AND EQUIPMENT**

Medium willow charcoal sticks
Derwent dark charcoal pencil
220gsm (100lb) cartridge paper
Putty rubber
Tortillons or paper stumps
Sharp craft knife

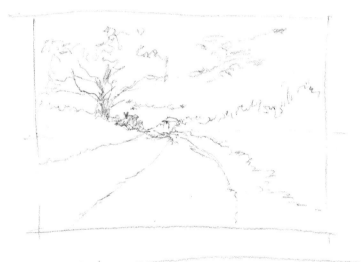

## Step 1

My first step was to make a rough sketch using the tip of a stick of charcoal to get the basic elements in place.

## Step 2

Still using the stick, I added the dark trunk of the tree and bushes on the left. I smudged in the leaves with a tortillon and applied the same treatment to the rest of the picture.

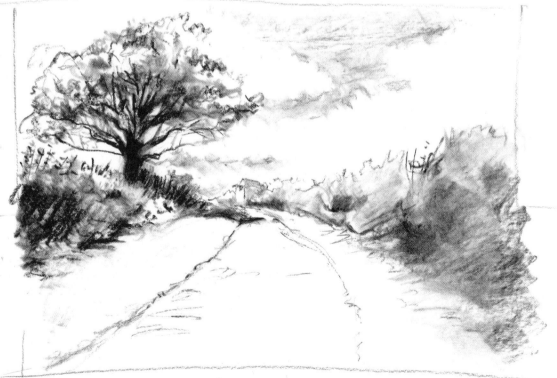

## Step 3

Using the side of the stick, I blocked in a dark area of the sky, leaving the white of the paper as the clouds. I softened the area with the tortillon, along with the lower part of the clouds. Using the tip of the stick, I roughly put in the bushes as a black mass, then, with the point of the tortillon, I drew the shapes in the bushes before lifting out some lighter lines with a putty rubber. I added some tone to the grassy verge, then drew into it with the tortillon and putty rubber. I smudged in some tone with my finger on the small house and added darker tone to the leaves in the trees.

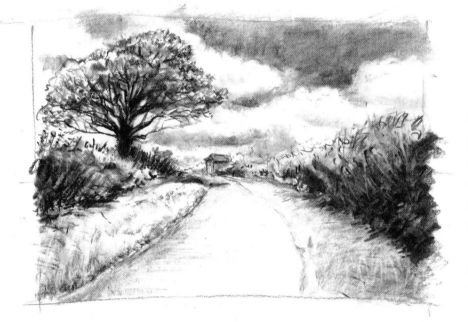

## Step 4

I decided to add more tone to the road and then deepened the shadow of the tree using the charcoal pencil. I stepped back for a final look and decided I needed a bit more sky, so, using the side of the charcoal stick, I enlarged the sky and drew more of the clouds in with a putty rubber.

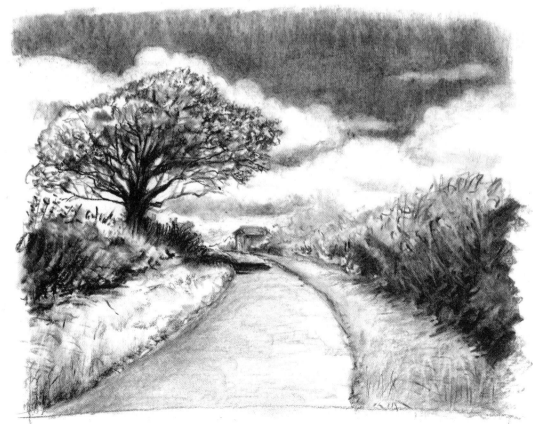

# CHAPTER 6

## The Built Environment

The term 'built environment' describes the urban landscape we tend to ignore as we hurry through it on our way to work or to go shopping. Even if you live in an apparently ordinary town, if you take the time to look at the everyday things you're bound to see something you hadn't noticed before – the variety of colour in brickwork, the design of some wrought ironwork, the shape of wooden windows and doorways and the patterns on the pavement.

In this chapter I've drawn a variety of manmade subjects, some designed for beauty as well as utility, others that might appeal only to the eye of an artist. Once you've tried following some of these step-by-steps, go out and explore your own environment to find subjects both large and small that appeal to your imagination. You'll find that you will never take your surroundings for granted again!

# Door

This door is in the historic English town of Lavenham, in Suffolk. I love old doors, especially beautifully crafted ones like this. The texture, grain and metal pins attracted me initially and the door was slightly smaller than normal. What lies behind that door? Where does it lead? I decided to draw the door first, before letting my imagination take me through it.

**MATERIALS AND EQUIPMENT**

3B pencil
Black artists' sketching pen or a permanent ink, black, fine felt-tip pen
0.2mm, 0.5mm and 0.8mm drawing pens
Grey pastel
Medium willow charcoal sticks
220gsm (100lb) cartridge paper
Putty rubber

## Step 1

I decided to use mixed media for this subject, starting with a quick pencil drawing in which I kept the details to a minimum.

## Step 2

Next I inked the whole drawing, using the drawing pens for the fine detail and the artist's pen for the thicker, looser work around the doorway.

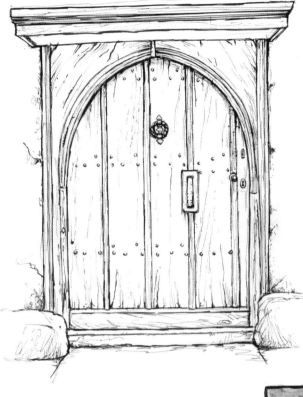

## Step 3

I worked all over the door, describing the cracks and grain of the wood and adding the letterbox and doorknocker as well as the other smaller details. I suggested the cracks in the wall and put in some dirt and debris here and there. With the ink drawing finished, I could move on to the next phase.

## Step 4

Next I rubbed grey pastel into the middle of the door, creating a rough, worn texture. I then drew into the rest of the doorway and stone with the pastel, but smoothed this in as I wanted the middle section to look the most weathered. Finally I switched to a stick of charcoal to add a dark shadow under the arch of the door and blended this in with my finger.

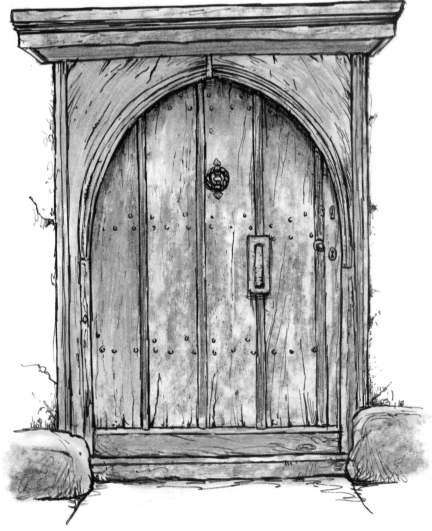

# The Flatiron Building

The Flatiron Building is one of New York's
iconic skyscrapers.

**MATERIALS AND EQUIPMENT**

Derwent Dark Wash 8B watersoluble pencil
220gsm (100lb) cartridge paper
Putty rubber
Tissues

## Step 1

I began by establishing the form of the building, which
is unusual in that its triangular shape means it has
a two-point perspective even when viewed straight
on (see pages 82–83.) I drew in the centre using the
windows to guide me, and then put in the outlines of the
surrounding buildings.

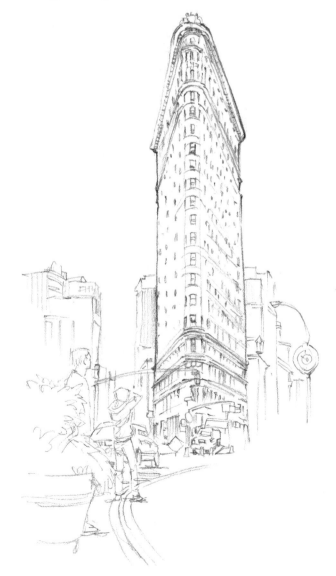

## Step 2

Next I spent time on the detailed stonework at the top
and then worked my way down the building, suggesting
the receding windows with simple lines and adding
some details here and there. I added some human
figures and a car on the left that were in my reference
shots to give some scale and to make the composition a
bit more interesting.

## Step 3

Then I extended the road to bring the viewer straight into the picture and put in more buildings in the distance. I included a passing yellow cab for character.

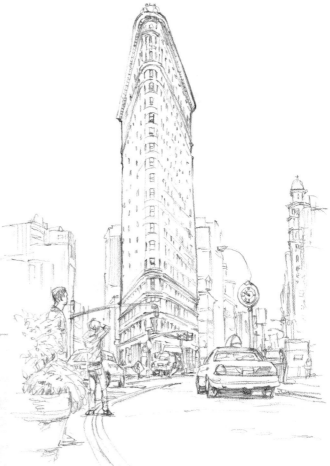

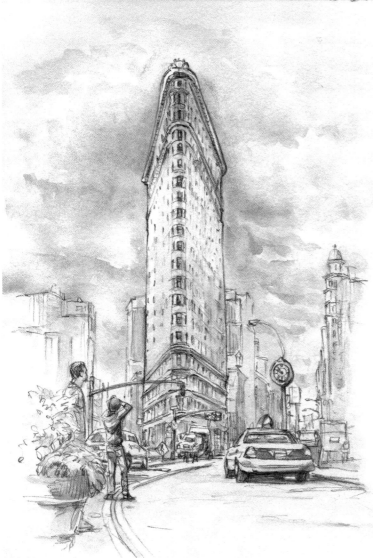

## Step 4

I laid down a heavy tone of the watersoluble pencil on a separate sheet then, using a wet brush, lifted off the tone to paint in the sky. I did this quickly, adding some fresh water to soften it where I felt it was too dark. While that was drying, I loaded my brush with water and painted into the rest of the drawing, keeping a tissue to hand to mop up overspills and lift any parts that were darker than I intended. I kept everything fairly light and just reinforced the shadow areas with darker tone where needed. Fading the wash towards the bottom was another means of drawing the viewer into the picture.

# Courtyard

I came across this courtyard in Bologna, Italy, and took some photos to work from at a later date. All the angles seemed at odds with one another and that's what made it interesting to draw.

**MATERIALS AND EQUIPMENT**

3B and 4B pencils
220gsm (100lb) cartridge paper
Putty rubber

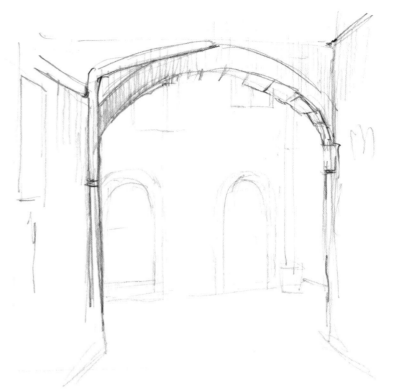

## Step 1

I began by using a 3B pencil to start sketching in the main alleyway leading to the courtyard beyond the archway.

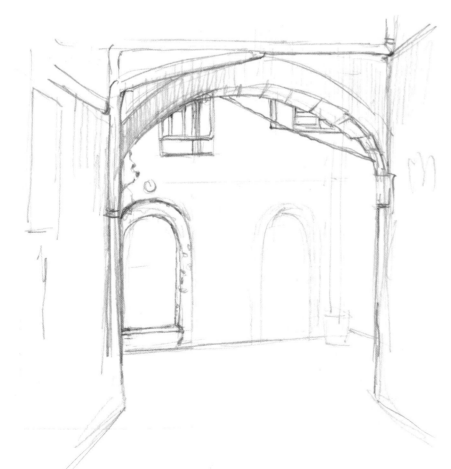

## Step 2

I added details to the archway and began work on the interior, the doorway on the left and the window above.

## Step 3

After elaborating on the doors and windows, I started to show the deterioration of the concrete walls and stonework. I drew in the little plant tucked into a hole in the wall, then tidied up the strange pipework above the archway.

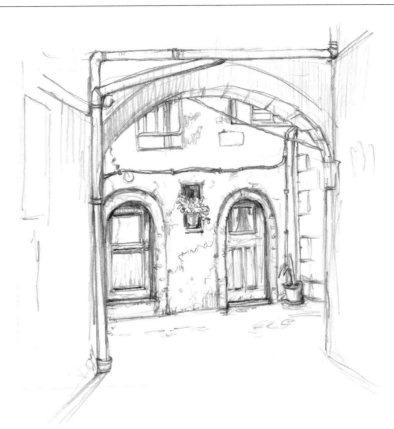

## Step 4

Next I did further work on both doors, adding all the details in the door-frames and wrought iron. The lighter tones were done with the 3B pencil and the darker tones with the 4B. I put in the tone on the walls of the alleyway, suggesting their damp, crumbling texture. I gave the archway the darkest tone and kept the ground beneath pale to show where the light hits it. Finally, I added some more texture to the ground, with a few cracks here and there.

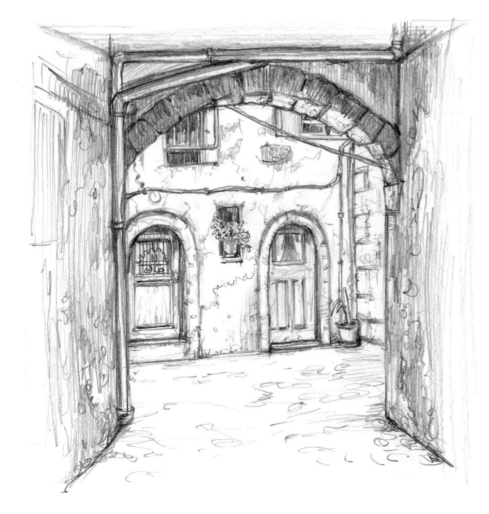

# Sagrada Família

Barcelona is a wonderful city to visit, especially if you've come to see the architecture of Antoni Gaudí. The highlight is the Sagrada Família, a cathedral that is a UNESCO World Heritage Site. This building is quite daunting to draw. The trick is to walk around your subject and look at it from different angles until you find one that suits what you want to achieve. I managed to find this view that showed me the main towers and the entrance; the foliage at the bottom creates a nice vignette to finish the drawing off.

## Step 1

I started off with a loose sketch, as this was to be a wash drawing with all the tonal detail added later. I made no attempt to draw every detail – what I could see through half-closed eyes was enough.

## Step 2

I continued to work on the spires and added in the scaffolding – the building is still incomplete. I varied the weight of the pencil in places so that I would be able to wash in darker tones where they were needed.

### MATERIALS AND EQUIPMENT
Derwent Dark Wash 8B watersoluble pencil
No. 8 round watercolour brush
220gsm (100lb) smooth cartridge paper
Putty rubber

## Step 3

Once I had sketched in all the spires that I could see,
I drew the rest of the scaffolding and the crane.
I added some tone and fleshed out the foliage.

## Step 4

For the final stage, I loaded my brush
with water and began to wash in the
shadows, letting the water soften and
bleed the pencil. As the sun was to the
right of the building I did this mainly
on the left of the spires, leaving white
highlights where the sunlight caught
them. The secondary shadows were
cast by neighbouring spires. Finally I
moved on to the trees, brushing in tone
as before and fading it out at the edge
of the drawing.

# Barber shop

All drawings are essentially visual stories and you want to guide your viewer gently into or around your picture using composition. If you look closely at the finished piece you'll see the bin bags at the front guide your eye to the line of the doorway. This acts like the shaft of an arrow, leading up to the triangular awning which points to the main focus of the people in the shop.

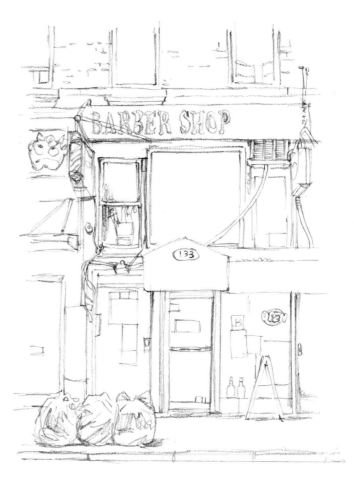

## Step 2

The frontage seemed to have wires and cables strewn everywhere. I began to put them in, along with little details of the windows and doors and some of the neighbouring shops.

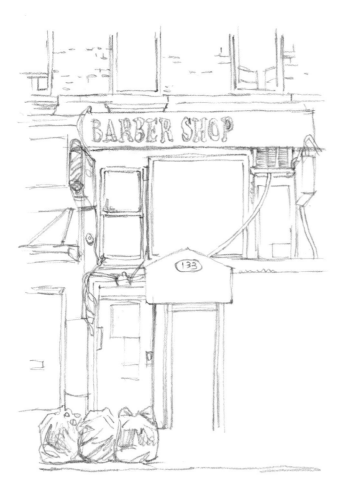

## Step 1

I quickly roughed in the storefront, noting the wobbly verticals and horizontals in this old, dilapidated building and the garbage bags outside on the pavement. The top half of the building is used as a barber's shop and the ground floor is an Indian restaurant.

### MATERIALS AND EQUIPMENT
Derwent Dark Wash 8B watersoluble pencil
No. 8 round watercolour brush
220gsm (100lb) cartridge paper
Putty rubber

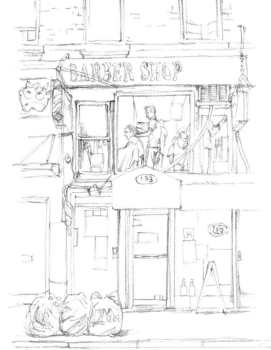

## Step 3

With most of the shop front drawn, I sketched the interior, starting with the two main figures by the window. One barber is half-hidden between the windows and you can see others in the rear of the shop.

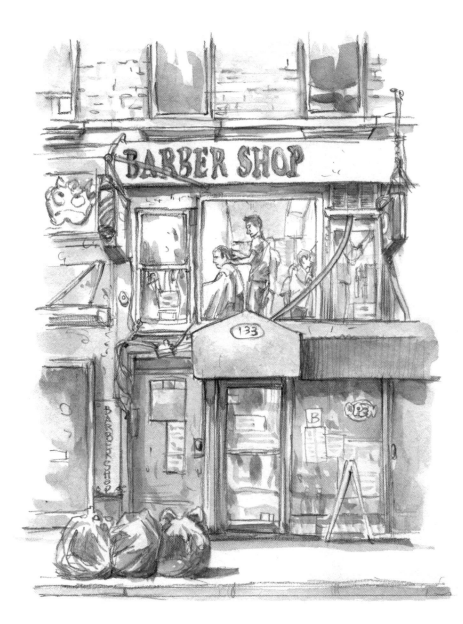

## Step 4

Now that all the details were in place, I put down the pencil and loaded my brush with water. First I washed into the lines of the window frames and guided the tone into little reflections from across the street. In other areas I let the wash find its own way, creating shadows and tone under the brickwork, doors and windows. I painted tone on the awnings but they dried too light, so I went over the lines with the pencil and then added another wash to darken them further. I darkened the main figures and left the ones behind much paler to suggest them receding into the distance. I added little details in the restaurant's menus and signs and kept the darkest wash for the garbage bags in the foreground. I finished by putting some shadows under the bags and in front of the building.

# Tree-topped tower

I saw this tower while on holiday in Florence. I climbed the opposite tower to get a better look and took some reference shots. When you want to draw something but can't stand far enough back, look for a vantage point from which you might be able to get a better view and a different angle. Take your time and look around, doing some quick sketches from different views, then you can decide which one appeals to you most. Don't settle for the obvious view; find something different that no one has done before.

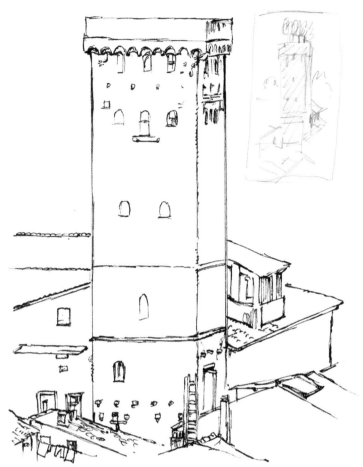

## Step 1

I decided to be brave and start drawing in ink from the outset, using pens of three different sizes to get a good variation in the line weight – you may prefer to do a pencil sketch first. I outlined the basic building shapes, including the surrounding houses, adding some of the window details as I went along.

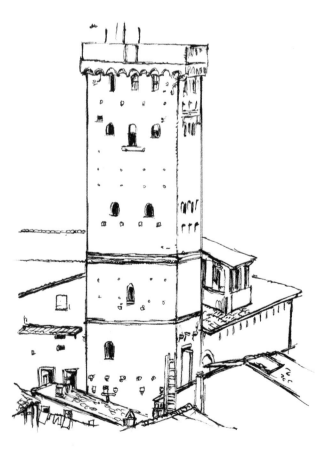

## Step 2

Using the thickest pen (0.8mm), I went over the outline of the buildings. I added all the dark windows and doors and then suggested the position of the rooftop tree trunks on the left.

**MATERIALS AND EQUIPMENT**

3B pencil (optional)
0.2mm, 0.5mm and 0.8mm drawing pens
Bleedproof marker pad, 70gsm (20lb)
Putty rubber (optional)

## Step 3

I used the thickest pen to put in the tree shapes, then switched to the fine pen (0.2mm) to draw some figures on the tower. I drew in all the fine details of the trees and buildings in the background, using the fine pen to help create the illusion of distance. I began to suggest tiles on the roofs – I didn't want to draw every tile as it's more interesting if some things are left to the imagination. I also started to add in the shadows, using fine lines at the back of the church.

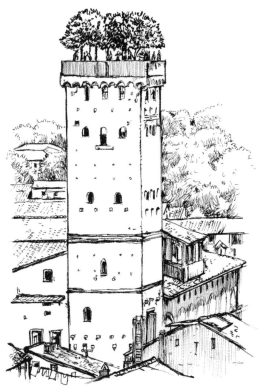

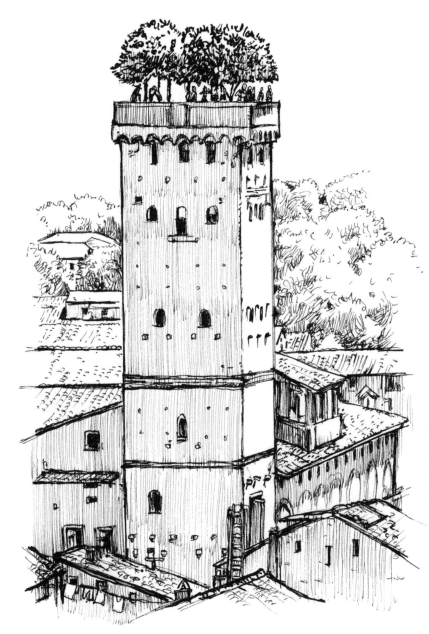

## Step 4

I finished by adding all the shadow on the buildings, taking my time to do this with vertical lines. Some more details on the roofs, chimneys and washing line completed the drawing.

# Falling down house

It's good to give yourself a bit of a challenge when drawing as it helps you hone your skills. I loved the fact that these buildings were at odd angles, but were still habitable and refusing to fall down! The trick to a drawing like this is to make sure your vertical lines remain vertical within the shape of the building, even if it is leaning at an odd angle. You have to imagine that if you straightened them up they would match the rest of the building's vertical lines.

**MATERIALS AND EQUIPMENT**

3B pencil (optional)
0.2mm, 0.5mm and 0.8mm drawing pens
Bleedproof marker pad, 70gsm (20lb)
Putty rubber (optional)

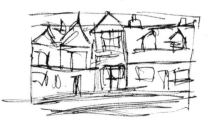

## Step 1

I worked in ink from the outset, but you may want to do your initial drawing in pencil. I started drawing in the basic shapes of the buildings, which proved to be a little tricky as everything was at odd angles. I worked first on the middle house, which was fairly straight apart from the top section, and took my guides from the lower part of the pavement. Even though the buildings were misshapen, the perspective still needed to be correct.

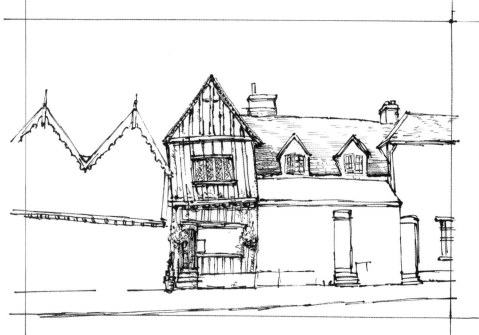

## Step 2

Swapping between the pens, using the fine one for the details and the thicker ones for the shadow and outlines, I drew in the architecture of the middle house first, together with a bit of the roof of the house to its right. I added some shadow on the roof and some horizontal lines to suggest the roof tiles.

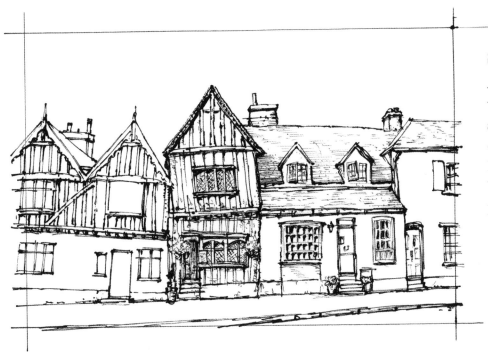

## Step 3

After finishing the details of the middle house, I added some suggestion of plant pots at the doorway to give some character. I moved on to the other buildings, alternating between pens as before to add fine or heavier details to the windows, doors and chimneys.

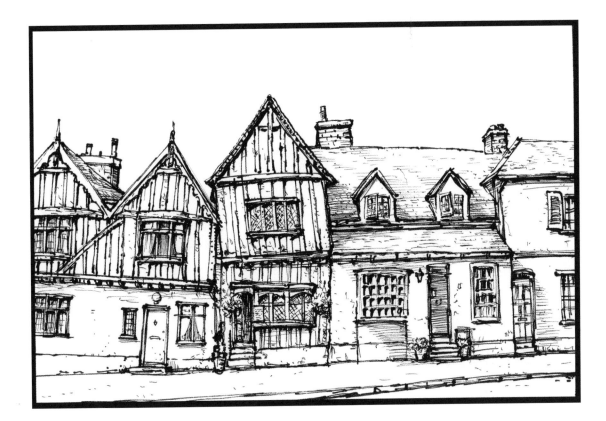

## Step 4

I completed the two buildings on the right, using horizontal lines for the shadow areas on the doors and round the windows. Then, to give the buildings some character, I added lines and dots to suggest wear and tear. I did the same to the pavement, but kept this to a minimum to prevent the drawing from becoming messy. Finally, I finished the building on the left.

# CHAPTER 7

## Drawing Pets

Getting your pet to stay still long enough for you to make a drawing may be difficult, so you need to pick your moment – cats, in particular, spend a lot of their time asleep, and the best time to catch a dog in a relaxed pose is after a long walk. Working from a photograph is a good way to start, then you can move on to sketching from life when you're feeling more confident.

As before, I've approached these step-by-step demonstrations in a simple fashion, starting most of them with a quick doodle to loosen up my hand, then building them slowly over four stages. I've added hints and short cuts to help you have fun with these drawings. So sit back, have a read through then get out your art materials and start sketching!

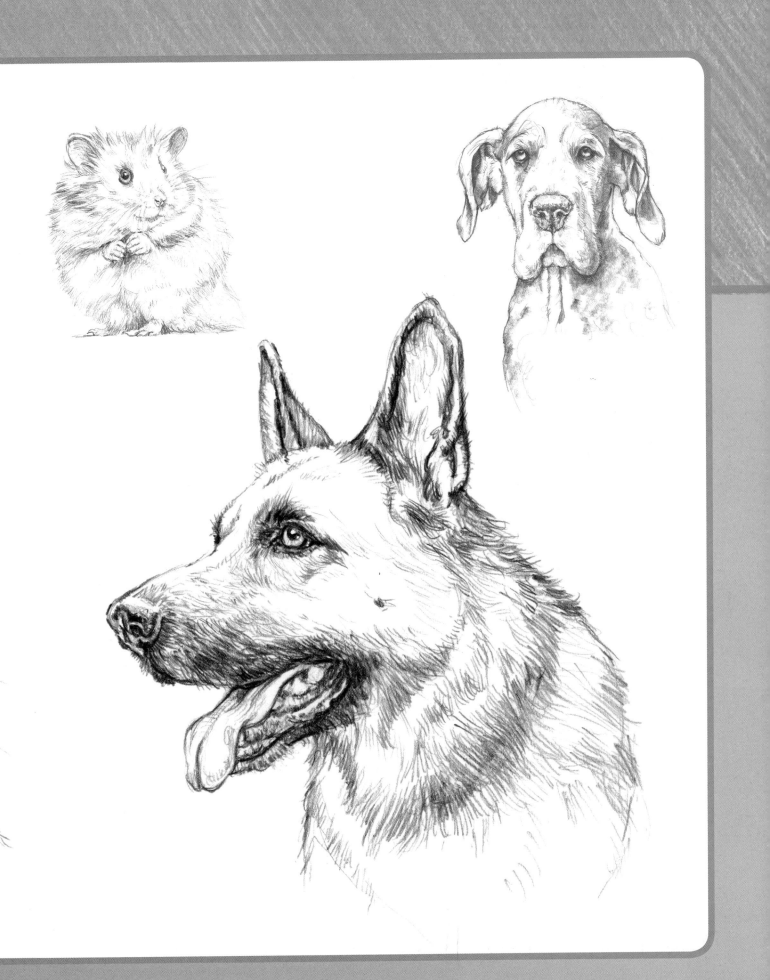

# Great Dane puppy

I drew this puppy from a photo – most puppies are far too lively to draw while they are awake! Each dog has its own character, and the soulful eyes and big floppy ears made me want to draw this one.

**MATERIALS AND EQUIPMENT**
Derwent Dark Wash 8B watersoluble pencil
No. 8 round watercolour brush
220gsm (100lb) cartridge paper
Putty rubber

## Step 1

After making a quick doodle, I started making a rough outline of the puppy's head and shoulders. Keeping my pencil line light, I took care to position the features and get the proportions right.

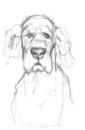

## Step 2

I started work on the eyes, putting in the eyelids and the blacks of the pupils. Establishing the eyes first helped me to get the character and mood right from the outset. I put in the area of shadow at the top of the eyes but not the whole eye, as I planned to use a wash of water later for a soft effect. Next I moved on to the nose and mouth, following the direction of the dog's hair to create the edge of the nose. With the light coming from above and to the left, I started to add the darker tones, allowing for the reflected light under the nostrils that bounced up from the floor. I left plenty of white areas because at the end I would wash a mid-tone over these.

## Step 3

I started shading in the tone around the head, eyes, ears and neck – most of the dark areas were on the right-hand side. I kept the end of my pencil firmly tucked into the palm of my hand to create this tone, especially around the neck and shoulders. I finished here with some finer lines around the eyes and lip area.

## Step 4

I could have left the drawing like this as it was almost done, but I wanted to add a wash of water to define and darken some parts and soften the tone. I worked in all the areas where I had left really dark tones, creating areas such as those under the jaw and jowls to make the dog more three-dimensional. Once I was satisfied, I quickly added some fine whiskers here and there. Where the whiskers crossed into dark areas I used a putty rubber like a pencil to draw them in white. Finally I used the putty rubber to lift out highlights in the eyes.

# White cat

This cat has such a noble look – I loved her expression and wanted to sketch it to capture the determined look in her eyes. I also wanted to draw her so it was obvious that she was a pure white cat. I think I achieved this by keeping the tone to a minimum and using contour lines for the direction of the cat's fur.

**MATERIALS AND EQUIPMENT**

3B and 4B pencils
220gsm (100lb) smooth cartridge paper
Putty rubber

## Step 1

I made my initial sketch of the cat, making sure I had all the proportions right and establishing the alert expression.

## Step 2

Next I spent a lot of time working on the eyes, using the 3B pencil for the iris and the 4B for the dark pupil. I didn't colour the entire eye – just the little pattern that radiates out from the centre. I added in the dark shadow and the lines around the eyes, keeping the area beneath them white to show where the light fell. Next I worked down the nose, showing the direction of the fur, and took a lot of care with the mouth, getting all the details of the top lip and chin just right.

## Step 3

The light was from above and to the right, so I started to add the shadow areas in the ears and the side of the face and neck on the left. I wanted to maintain the white of the fur, so rather than block in all the shadow in the ears I carefully drew in the little hairs in front and then added the tone to the negative shapes in the ears. I applied the same technique to the whiskers and then used the contour lines of the fur to help me draw the sides of the head and neck.

## Step 4

To complete the drawing, I went over the darkest shadow areas on the mouth, cheeks, nose and side of the head with the 4B pencil.

# Hammy

Although this hamster may look like a fluffy ball, it's important to make sure your drawing gives an impression of the skeleton and muscles under its fur or it just won't work. Looking closely at the contour lines of the fur and following them will help to create a believable animal structure and form.

## Step 1

I began with the usual doodle before moving on to the main drawing, when I started fleshing out the character of the hamster with the 3B pencil. My aim was to use mainly contour lines to draw the figure in this step-by-step.

## Step 2

Next I worked on the head downwards, adding the dark tone in the ears, then, using the 4B pencil, I put in the dark tones on the cheeks and around the eyes. All the light tones were done with the 3B pencil and the dark with the 4B. I shaded in the eye colour then added the dark pupil, leaving the white highlight.

**MATERIALS AND EQUIPMENT**

3B and 4B pencils
220gsm (100lb) cartridge paper
Putty rubber

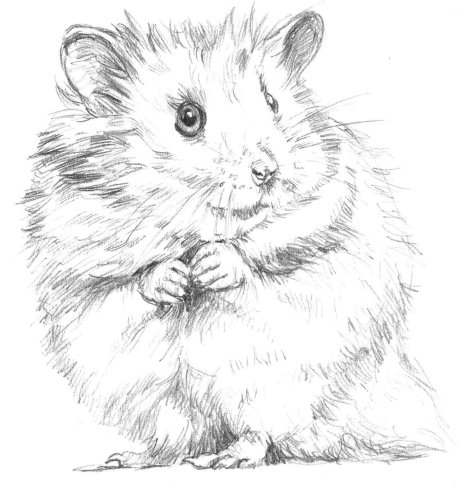

## Step 3

I added a little detail to the nose – just enough to make it stand out. The hamster looked a bit worried, so I changed his mouth to suggest a slight grin. I started to layer the fur on his shoulders and worked in some detail on those delicate little paws. To make them stand out more I added a darker tone beneath the chin and the paws. I wanted to be able to see some sort of form for the forelegs, so I used contour lines to suggest their presence in what is essentially a walking ball of fur.

## Step 4

I continued as before, working my way down the body and adding darker tone to suggest the hind legs under there. I drew in the back feet and toes and drew a few lines for the tail. A tiny shadow under his feet to ground him was the final step.

# German Shepherd dog

This is an example of how to draw animal heads using simple shapes. Here I've used a box for the skull, cone shapes for the nose and jaw and triangles for the ears.

**MATERIALS AND EQUIPMENT**
3B and 4B pencils
220gsm (100lb) smooth cartridge paper
Putty rubber

## Step 1

After making my geometric doodle, I started the main drawing and set to work capturing this beautiful dog's head. I lightly sketched in the main features with the 3B pencil, then switched to the 4B for the darker areas.

## Step 2

Next I worked on the eyes to establish the dog's character. I drew in the pupil, leaving a white dot for the highlight, then put in the dark skin around the eyes. I worked on the eyebrow before adding more detail to the nose to give it definition and shape. I added dark tone round the mouth and lips, then drew the dog's 'mole' on his cheek.

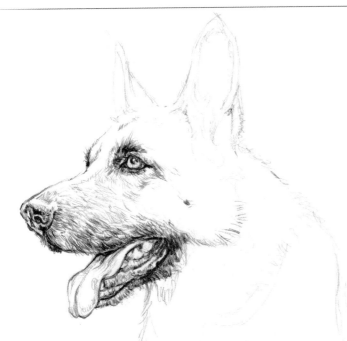

## Step 3

After working on the gums and mouth, I added the dark shadow on the tongue, then emphasized the bulge under the skin where the back teeth push through. I moved up the cheek, adding in the dark hair all the way to the nose, and then put in the dark tone of the nose with little circles to create the characteristic bumpy texture.

## Step 4

After putting detail and tone on the ears, I worked down the back of the neck, following the shape of the coat with contour lines. I did the same around the jawline and under the neck. I returned to the side of the muzzle and added more tone, then finished with contour lines under the eyes.

# Pretty Polly

Parrots are great birds to draw – they have such strong characters and their tiny eyes are filled with mischief.

**MATERIALS AND EQUIPMENT**
3B pencil
Brush pen
No. 8 round watercolour brush
220gsm (100lb) smooth cartridge paper
Putty rubber
Tissues

## Step 1

I did a quick doodle to warm up, then started on the main sketch, keeping the drawing fairly light as I planned to go over my line work with a brush pen. I paid close attention to the eye to capture some of the character in the bird. I carefully sketched in the little lines around the eye which link up to the feathers at the side of the eye and beak. Then I suggested some of the pattern and cracks on the beak.

## Step 2

Next I started to go over my pencil work with the brush pen, faithfully following the drawing. I darkened the inside of the mouth and added some shadow under the beak.

## Step 3

Once I had finished following the line drawing I started to add more of the feather detail under the beak, all the time varying the weight of my lines.

## Step 4

I loaded my brush with water and let it pool along the dark line of the beak, just beneath where the highlight would be, softening it and creating its own little pattern along the beak. I gently dabbed my brush on some tissue to get rid of excess water, then dragged it along the top line of the beak to soften the edge and create the cracked pattern. I lifted off ink here and there and dragged the tone along the beak and down to the tip. Next I worked on the tongue, softening the dark shadow at the front and pulling the tone into the mouth, taking care to leave a small highlight. I took the tone all the way up and out and added the creases around the mouth. I started on the lower half of the beak and again used the loaded brush to drag the tone around. Taking care to leave the white of the paper to suggest the cracks and lines, I flooded the area with tone to finish the drawing.

# Index